COUNTRY BOY

SELECTED POEMS

BY

WALTER S. STAPLES

Peter E. Randall Publisher LCC
Portsmouth, New Hampshire
2004

Peter E. Randall Publisher LCC
Box 4726, Portsmouth, NH 03802
www.perpublisher.com

Additional copies available from
 Jim Staples
 139 Lower Ridge Rd.
 Loudon, NH 03307

ISBN: 1-931807-28-0
Library of Congress Control Number: 2004109910

PREFACE

Everyone writes poetry. It is an expression of appreciation for something very special whether it be love, a sunset, fall foliage or deep thoughts that cannot at the time be otherwise shared.

These are some of my poems.

They attempt to show my deep appreciation for the wonders and beauty of the natural world and the people I have known during a long and eventful lifetime.

THE WORDS I WRITE

They are my company,
 The many words I write
 Along my lonely trail
The thoughts that come to mind
 But fleeting dreams at best
 Unless I write them down.
The tracks I see in snow
 That lead to merry chase
 Of hare and beagle pup
The stream beside the road
 With beaver fish and things
 Along the length of it
The rainbows after showers,
 The woodchuck stumps I see
 The robins, jonquils, Spring!
Each line and page reminds
 The thought, the thrill, response
 To wondrous things I see,
Each thought a fertile seed
 Expanded on perhaps
 Like acorn grows to tree.
It does not slow the time
 But like a photo holds
 A passing thought, a scene,
That quickly could be lost;
 But I will write it down
 To keep me company.

CONTENTS

COUNTRY BOY

I can't imagine childhood spent
Without a gray-haired grandma near
To kiss the hurts, wipe tears away,
Both parents there, not just at night
But on the farm throughout the day,
The drifts of snow we had to climb
From first grade on our way to school;
To never see the chicks burst out
Through broken shells of big brown eggs,
To hear the clucks of mother hen
When calling chicks to share a worm
She scratched from in the garden patch.
Her feathers cover chicks that hide
At warning shriek a hawk flies near;
With never watching baby calves
That try to stand on wobbly feet
While searching for their mother's milk
And mooing mothers lick them clean
And when the strawberries were ripe
To pick a hundred boxes full,
Help whip the cream to top shortcake.

I can't imagine growing up
Not skating on a frozen pond
With fire to light the party night;
No squeals of pigs at killing time,
The smell and taste at breakfast time
Of home-smoked bacon being fried;
Of pulling weeds on hands and knees
From long, long rows of carrots, peas;
Not holding reins for raking hay,
The horse too old for heavy loads,
And shedding shoes when school was out
To walk barefoot the summer through.

I can't imagine city-raised
Without green grass, no trees to climb
No faithful dog to follow me
Across the pasture after cows;
No kitten waiting for warm milk
When milking done, the cattle fed.

I had to be a country boy,
I can't imagine otherwise.

THE EGG

Did ever you hear the peck, peck,
Then peep, peck, peep inside an egg,
And see the spot where first the shell,
Just one small spot, is broken through?

Have you then watched while from inside
A tiny chick will turn and stretch,
Then break the shell and then emerge,
A soggy lot of wings and legs?

With rest but brief between each try,
And in this time while drying off,
At last it stands and does not fall,
A tiny, yellow, ball of fluff.

It pecks at food and searches heat
And one may tell from pitch of peep
If happy, hungry, wet or cold.

Within a year, what was an egg
Is then producing more of them.

A B C'S

A tree I cut today
 Had long and twisted limbs,
Was just another tree
 To cut and trim for wood,
Save limbs were big enough
 To stoke the kitchen stove
When cut to length and dry
 About a year from now.
But then I saw the 'O'.
 A limb was bent by snow,
Perhaps a falling branch
 From this or other trees,
Was turned, grew up and back,
 Went by but touched itself
And formed the letter 'O'
 While reaching for the sun.

I thought of long ago,
 Finding the alphabet,
A maiden aunt with four
 And sometimes more like me
About the age of six
 In woods across the road
From where we used to live,
 We looked above at limbs
And found the A B C's.
 We saw the birds and nests
And squirrels high above
 And learned the names of trees,
The maple, birch, and pine,
 Picked flowers as we went,
And learned to find our way
 Back to the road and home.

I'll look again today
　　When I am cutting trees,
For letters in the limbs
　　That make the A B C's

APRIL

I want to hear the peeper frogs
Beyond the willow trees
While walking on the causeway path
That dams the little stream.

I want to hear the honk of geese
Above the morning fog
And see the last of winter ice
Dissolve in April rain.

I want to pick the willow buds
On long and slender stems
And find the first wild violet,
The proof that spring is here.

SHOES

Just in my teens I visited
My cousin Don in Kittery.
While there I wore my shoes,
The ones I kept for fall and school,
Except when we went in the house.
Your see Aunt Bea made kids leave shoes
And all their dirt somewhere outside.

Out on the farm where I grew up
We wore no shoes in Summer time.
With arms piled high with firewood
To fill the box behind the stove,
Quite difficult to take off shoes;
And water brought by buckets full,
A task that kept hands occupied.

Though true there were no chores to do
When visiting with cousin Don,
It seemed to me we had more fun
When it his turn to visit me.
Out on the farm without Aunt Bea
He wore no shoes, went barefoot too.

DEVILS

The devil's one I never met
Though heard his name a many times.
I think I knew folks worked for him,
Perhaps should say, for one of them.
There must be more than one or two
With so much devil's work to do.
The one that I now have in mind
Is one that Grandma warned me of
Each time she found my chores not done.
He was the devil who found work
For idle hands of little boys.
And when she spoke of him to me,
Her tone of voice was sinister;
Her whispered hiss filled me with awe.
The devil sure was big and strong;
His voice alone, without a lash,
Enough to frighten little boys.

Though then I felt that Grandma left
Too little time for little boys to play,
It's true the devil never had
To find some work for me to do,
Not much, that is, not very much.

BY YELLOW VIOLETS

I love the little brooks
 That frozen into ice
And buried under snow
 Will challenge in the spring.
Though frozen more than once
 Because first thaws are false
And winter fights to stay,
 In time the brook will win.
At first a murmur there
 Beneath the ice and snow;
And then where brook will bend
 It carves a breathing place
And tinkles like a bell
 Before it's lost again.
Each sunny day it's fed
 By melting ice and snow;
In places breaks the ice
 And soon to run all free.
Where snow was deep before
 With silent brook beneath
A stream runs merrily
 Near yellow violets

FIRST LOVE I

Among the rugged limbs
Of this still sturdy beech
To where I then had climbed
I found my father's 'V'
Dull jackknife carved with 'L'
While sitting on this limb
Some twenty years before.

While on that same beech limb
I carved my 'W'
A heart and letter 'M'
She never knew I did,
A secret that I kept
As boys were apt to do.

TO BUY A FARM

I am the only one
Who now remembers all,
My children still recall
The friends they left behind,
The sidewalk and the schools,
The borrowed truck we used
To move out to the farm.
They hardly thought at all
Of things their parents did;
And now their mother's gone.
I am the only one
With thoughts they did not have.
Was that old run-down farm
Where children should be raised?
And was it safe for them,
A mile to walk to school
Along a country road?
The village doctor old,
The nearest hospital
Long thirty miles away?
And could I ever pay
The mortgage if I signed?
The sprawling sagging house
Would need a coat of paint
And shingles for the roof,
Perhaps a sill or two.
Five chicken houses there,
Each one to need repair;
Neglected space between
With bushes, weeds and stones
Where gardens must be grown,
The fences down where pigs
And sheep would stay again.

Of course I asked advice
Before I then agreed
To sign on dotted line.
The first experienced
In running poultry farms.
He came and patiently
Walked through each chicken pen
While I explained that I
Would somehow find the time
The tools and money too,
Someone to show me how,
To patch the holes in walls,
Replace the rotten sills,
Dig up the rusted pipes
That brought the water from
A spring I had not seen.
Then in the weed grown drive,
Beside the sagging barn,
With all sincerity
He scratched a match and said,
"My boy, there's nothing here
A match will not improve."

I brought my Dad to see
This mountain chicken farm
And hear the plans I had
To make it home for me,
My wife and family.
A farmer all his life,
I hoped he'd see beyond
The need for glass and paint,
The sweat and toil he knew
Would have to be endured
Before my dream came true.
We walked across the fields
Where furrows must be turned

Before I planted there.
We found the cold deep spring,
No end to water there.
"The boys will help with chores,"
He said, "As once you did;
The girls will help inside.
There's always work to do
And all must help on farms."
Back on the shaded porch
We sat and talked a while.
I listened while he told
How he had run his farm,
How much we boys had helped
By picking beans and peas,
Searched pasture for the cows,
Brought water from the well
And kept the wood box full.
He lit his pipe and said,
"Though I'm at sixty-five
I make a living now
At home there on the farm.
The times have changed a lot
Folks want a whole lot more
Than when you were a boy.
Your boys and girls will want
More than you ever had.
There is no way that I
At sixty-five would try
To bring this old farm back
But if I were your age
I'd know I could, and would."

My banker once had been
A logger in the woods,
Then went to sawing logs
And bought and ran a mill

When war pushed prices up.
"Let's see what's in the woods;
I know what trees will bring,"
He said and followed me
To scale the pine and oak
With practiced eye on all
Two hundred acres, then
Agreed the bank would loan
The value of the logs,
Enough to buy the farm.

The pressures made us move
Were pushing, pulling, both.
The house in town too small.
We had three boys, twin girls,
Another sure to come,
A garden ten by ten.
The neighbors did not like
The chickens in the shed,
That pigs were often out,
Their fence too frail to hold.
They called our place the zoo
And the neighbor's children
Seemed always gathered there.

I still would keep my job,
Be sure to pay the bills,
Grow food there on the farm.
I'd plow and plant at night,
Spend weekends driving nails.
The boys could pull the weeds
And do the outside chores.
The girls could pick up eggs,
Help mother freeze and can.
We'd live the healthy life,
The happy farming life.
Though not exactly as

The plans I made when young,
I am not sorry now
I chose to buy the farm.

TREES

I've seen the flame of Liberty
And pictures of the Taj Mahal,
The Eiffel Tower, pyramids,
The treasures held in museums;
But nothing made since time began
Competes in beauty with a tree.

New England waves on shores of stone,
The delta streams that feed the Gulf,
No canyon deep in rusted rock
Nor frozen peak of Everest
Can match response in mind and heart
To that a forest radiates.

If green of spring, fall foliage,
With Christmas snow or summer sun,
Their images will influence
The clothes we wear, the thoughts we have,
To where we go and what we do.
Though seasons seem to claim the fame,
What would they be without the trees?

ON LAND I OWN

I went beyond the field today.
I walked on patches white with snow
And patches brown with frozen leaves.
The sky so blue, the sun so warm,
It was the day to greet my trees.
I'd not been there when snow was deep,
The days so cold and trees asleep;
And though perhaps but half awake,
I think they knew that I was there.
Each tree stood firm when I reached out,
Leaned hard on it that I not fall,
Held tight a limb where hillside steep.
I rested on a sun-warmed rock,
Looked up the trunk to limbs above
Of one tall pine, a beech, an oak.

On land I own are they my trees?
Not so; though I may cut and kill,
The logs for boards and firewood
Be mine, the tree alive, like deer,
Raccoon and robins, squirrels, toads,
Are freeborn too, as much as I.

THREE TREES

Three trees
 Stood on the lawn,
 A lawn as such;
 The space between
 The road and house.
 It was not mown.
 The grass that grew
 Was mostly tread
 By little feet.
 The house not much,
 A shack to most
 When passing by;
 But home to those
 Who live in it.

Three trees
 One for a swing.
 One tree to climb
 And shade from each
 On summer days’
 All three to drop
 Their leaves in fall
 In noisy piles
 Where children play.

If still a child
 I’d choose three trees
 Between my home
 And country road,
 If choice were mine,
 To any house
 By city streets
 Without three trees.

LINE TREE

My father left it long ago
 When he cut wood to warm the stoves,
A tall pine then but taller now
 Still marks a corner boundary.
A blaze each side now overgrown
 Identifies this old line tree.

Some loggers cut the lot beyond
 And they too left the giant pine,
Although in felling other trees
 Some lower limbs were broken off.

The years have passed. It's time again
 To harvest logs on land now mine.
I shall not know if that old pine
 Has hollow heart or solid wood;
Because I too like father did
 Will let it stand to mark the line
Between my land and that not mine,
 As in the deed, one tall straight pine.

THE TREES I CUT

The trees I cut today
 Were pines, each tall and straight.
Though more than arms length 'round
 The saw cut through with ease.

I counted rings today
 On stumps of trees I cut
That measured time they'd lived,
 One eighty, one a hundred years.

It grew a hundred years
 And was six inches through
The day that I was born.
 There were good years and bad
With some rings thick, some thin.
 That may have measured rain.

Some crashed into the snow,
 Broke limbs from other trees,
Crushed some beneath their weight
 In final dominance.

I left a big dead pine
 Where birds in summer nest
In holes where bigger birds
 Had drilled to hunt for ants.

I wonder if a tree
 Would rather die and be
A home for nesting birds
 Or would prefer the saw
And crash alive in snow,
 Be cut and sized and planed,
Be made into a door
 Or picture frame or chair.

THE SAP HOUSE

It's time of frosty nights
And days of warm sunshine.
The buckets filled with sap
Hang close on maple trees
And drip on snow below.

A cloud of fog escapes
From vents in cupola.
The fire is stoked with slabs
Beneath the boiling pan;
The air is moist and sweet.

Put syrup on the snow
For party treat tonight
And lend a helping hand
To those who 'sugar off'.
Say thanks for maple trees.

THE WOOD PILE II

The shingled house was small
But big enough to heat
Come wintertime in Maine;
And big enough for two
Now married forty years,
The children moved away.
Perhaps the pile of wood,
Where could have been a lawn,
At angle from the road
From where I'd stopped nearby
Then maximized the pile
And minimized the house.
Although the wood not stacked,
Just random thrown to pile,
It still was round and neat
As if each stick was tossed
To fit a certain place.
The fresh split side shown bright
Like frosting on a cake;
So bright in fact I thought,
Expected that I'd see,
Another stick thrown up
And hear it clatter there.
Though none was in my sight
Some wood still round could be
Behind the pile from me;
But then I saw the man.
He sat upon the step
Before the open door;
His tattered hat pushed back
To let the sunshine warm
His weathered, wrinkled face.
One hand still held the axe,

Or seemed to rest upon
The upright handle end.
A woman stood behind,
Was looking down at him;
And though I heard no words
I'm sure of what they said.

"Come take a look," he'd called,
To signal he was done.
Then she said all the rest.
"It's such a pretty pile,
Seems bigger than last year;
It took more time to split."
"I'm glad the job is done;
Come have a cup of tea."

COUNTING TREES

I come to count my trees.
Well, that's not true, of course.
Two hundred acres here
On steep and rocky hills,
With pine and oak and ash,
Some hemlock, birch and spruce,
Hornbeam and hackmatack.
Too many here to count.

Perhaps I mean 'communicate',
Though words are not the way
That trees communicate.
The voices that I hear
Are whispers in the leaves,
The sighs of bending boughs,
A cone that falls on moss,
An acorn drops from high
To bounce from limb to limb
Before it hits the ground.

Birds add a melody
In languages their own
And each is understood.
My 'counting' just the way
I pass from tree to tree,
Or sit to look around,
Become a part of it,
For just a little while.

THE WIND

From safe inside these old log walls
I hear the howl of winds outside;
And like the howl that coyotes make
They speak in wild and varied tones.
They roar across the forest tops
But whisper near the forest floor.
They whistle past the cabin door
But wail beneath the windowsills.
Their breaths may cool an August day
Or carry snow to sting the cheeks.
They carry scent of new mown hay
And odors made by paper mills.
They come on moonlit winter nights.
They fill the sails on summer days.
They dry the clothes on Monday's lines;
But carry rain from thunderclouds.
Sometimes it seems they try to speak
Or sing or shout in witches tongue.
They play with dust and leaves and snow.
They feed a fire and raise the smoke,
May reach a fury never matched,
Or may like magic disappear.

WINTER CAMOUFLAGE

The storm had blown away
 And roads again were clear.
I drove along a ridge,
 Could see for miles beyond.
The snow on fields and lakes
 With stands of pine around
Were island in a sea
 Of windblown weaves of green.
So much, so deep the snow
 There were no ridges left
To mark where furrows plowed
 For planting corn in spring.
A patch of sparkling white
 Though near a house or barn
Might cover pasture rocks
 Or have a pond beneath.
No one from passing by
 Could see what lay beneath;
But whose who lived nearby,
 Who pastured, farmed those fields
Looked at each white expanse
 And saw what lay below.

WINTER NIGHT

When in your bed tonight,
And in the twilight zone
Before you fall asleep,
Imagine if you will
The moonlight on the snow
That I would share with you.

Mine are the lonely tracks
That mark the way I came
From road across the field
To trees that crest the hill.
From high above I see
The winter night below;
The white expanse of fields,
The frosted line of trees
That line the country road,
And yellow window lights
Of homes along the way.

I walk on shadows etched
Of slender trunks of birch
And leafless limbs above,
And note the buried walls
With distorted height and girth.
I pass a pointed fir
That caught and held the flakes,
Now wears an ermine coat
With sparkling diamonds.

The moon, the snow, adorn
The beauty of this night,
A soft and quiet night,
A lovely, lonely night;
One to be thankful for,
A night to dream about.

NO DOUBT

I must agree with you.
I closed the camp today
And left my hermit ways.
I washed my neck and hair
And cleaned my fingernails.
I found the clothes I wore
(Was it four weeks ago?)
The day that I arrived
And dressed in them again.
I burned the remnants of
The clothes I wore while here.
I closed each shutter tight
And barred and locked the door;
But where I had to stop
Along my lonely trail
And saw a mirror there
There was no doubt at all.
I do agree with you.
My beard has got to go
And I will shave tonight.

FREE TO DREAM

My world of Make-believe
Has rain as well as sun,
Has those who are alone
And seldom rendezvous
As well as those whose love
Will never let them part.

It's trees when rained upon
That sparkle with the dawn;
And on the blackest clouds
That brightest rainbows form.
There is no form or life
To canvas black or white
There must be color there
For faces or a tree.

There has to be a ditch
Or roads will wash away,
And if no rocky shores
We'd have to live in boats.

My world of Make-believe
Must have its lonely trail,
Must know the cold at times
To recognize the warmth,
Be born of memories
But always free to dream.

BLUEBERRY HARVEST

So many times today
I thought of Bill McKeage.
Though many harvests now
I've winnowed by myself;
I came here first with him.
He'd worked in berry fields,
Had run the winnower;
Not difficult, you say,
And I of course agree;
But berries cleaned by some
Were hardly cleaned at all.
They still had leaves and sticks,
Some caterpillars too.
As if by magic touch
When Bill had winnowed them,
The boxes capped with blue
Were ready for the cream
And waiting for a spoon.
The pride that Bill then had
That kept his berries best
His legacy to me
Through many harvests since.

CHURCH SUPPER

Blueberry pie, blueberry pie,
How many berries in a pie?
How many cooks, how many pies?
How many tongues and lips stained blue,
How many stains on shirts and pants
From pie that somehow slipped from forks?
No cooks alike but each her best;
If crust too short or pie too sweet,
It still will be the favorite
Of someone there who came for it.
The wild sweet taste from fields turned blue
Where sun and fog and bees have worked;
And children bent with iron rakes
And buckets full were winnowed clean
Of sticks and leaves they also raked.
Their tongues and lips perhaps are blue,
Not waiting for a pie by made.
Blueberry pie, blueberry pie;
Please pass Aunt Maud's blueberry pie!

THE SEASONS FOLLOW

With passing of the day
That marks my date of birth
The seasons follow me.
The foliage at best
As maple leaves turn red
To dominate the day.
The harvest moon shines bright,
Brings romance to the night;
But morning brings the truth;
Another year has passed,
Is added to the rest
And looking back I know
There's been more summers passed
Than are ahead for me.

The winter follows me
In cold and slow response
As if to willingly
Attempt to hibernate,
My mind less active than
A field of frozen snow,
My thoughts if any left
Of all the love I've missed.

But then like bears in March
There's something gnaws my heart
And warmer blood is pumped
With urge to sally forth
In search of daffodils;
And sure enough comes spring,
Retarded some by frosts
But bringing buttercups
And apple blossoms too

With warmer sun each day
To follow me with cheer
Through all the summer days.

WELCOME RAIN

From South there's wind enough
 To make the leaves turn up,
 To bend the branches back;
But not a cloud to shade
 Me on my lonely trail
 From heat of summer sun.
I smell the fragrant blooms
 Of pink and white on trees
 And pass them as I go.
And now the smell of tar,
 The sight of sun-bronzed backs
 Of men who patch the roads.
The crickets hide from crows
 That stalk the roadside grass
 For something they might eat.
There's diesel engine smell
 And roar of giant trucks
 As many pass me by.
At last a thunderhead;
 The clouds build up from west.
 I'd welcome rain today.

FOR ME TO SEE

I often wonder if
 The woodchuck stumps I see,
A flooded muskrat house,
 Crows on a naked limb,
And seagulls in a field
 Are just for me to see
And write so much about
 Along my lonely trail.

Those puffy clouds I see
 After an April rain,
The green in farmers' fields,
 Sometimes at dusk a deer,
Wild waves that crash on rocks
 And sails far out to sea,
Are they for other eyes
 Or only mine to see?

CABIN FEVER

By winter's jaws I've long been jailed,
Pinned down until my patience went;
And like a bear I growled a bit.
But now I've climbed the prison wall.
The narrow trail for my escape
Is banked by snow for miles on end;
And like a tunnel labyrinth
Has one way out; the endless road
That's mine along my lonely trail.

The winter walls that penned me in
Were built of lack of things to do,
Of patience lost by others too,
The cold, the long and stormy nights,
The chore of clearing snow away
And pile that snow up higher still
To clear the self-same walk again.
But now breathe deep and look ahead
For winter's dreams to soon come true.

GUIDELINES

"The goldenrod is yellow,
The corn is turning brown."

"A tree who may in summer wear
A nest of robins in her hair."

"A thing of beauty is a joy forever,
It's loveliness increases...."

"The dark wharves and the slips,
And Spanish sailors with bearded lips"

"Four score and seven years ago
Our fathers brought forth
Upon this continent..."

"If I should die, think only this of me,
That there's some spot in a foreign field
That is forever England..."

Where did I find these words?
Not in the hidden scrolls
Nor an archaic dig.

I found them yesteryear,
Were stamped indelibly
Upon my memory
My first few years in school,
Read from my spelling book,
Recited by the class;
The treasured time and thoughts
That guide me still today.

EXIT

My road goes straight away
From all I leave behind;
My mail of trash and bills
And "gimmies" free of tax,
Familiar voices drowned
Among the TV sounds,
The phone that always rings
Or folks arrive when I
Am sitting down to eat,
Or more important things,
The ticking of a clock
Heard when I want to nap,
Those many little jobs
I've never time to do
(Replace a light bulb next
Or hang that picture now?),
Those barbecued pork ribs
Before the apple pie
That bring heartburn for sure
From spices and the sweets,
My rocking chair and bed,
The wood fire smell and warmth,
And happy memories.

I think when I get where
I've left it all behind
I'll find a phone and call,
Be sure it still is there.

ALWAYS

As long as I can pause
Beside a clover patch
And look for what some say
Will bring good luck to me,

As long as I can walk
Among the forest trees
And stand in awe by one
That I can't reach around,

As long as I can see
The mighty ocean tides
And hear the roaring waves
Crash on a rocky shore,

As long as I can watch
The sunset in the west
Reflect its hues on clouds
Before the darkness comes,

As long as I'm alive
See these and other things
That mean so much to me
It's what I'll share with you.

REVIEW

It's when my daughters, now grown up,
Start keeping prints of naked babes,
Of pictures taken while at school,
Perhaps their children's children too,
That they come home and ask to see
The pictures that I kept so long.
Not just the ones I kept of them
As naked babes or while in school,
With brothers, sisters and their friends;
But those of me, my Model "T,"
My hunting dog and my first deer,
My grade school graduating class....
And found at last, though hidden well,
My special book of memories.

They all were there, still in their teens,
By Kodak kept in black and white
At beaches in their bathing suits,
On snow banks in their fur-trimmed coats;
The pictures of the girls I'd known
At school, 4-H, and Epworth League,
The Parson's daughters (three of them),
A pretty girl I could not name.

So many questions asked of me,
So many thoughts that came to mind.
I wonder if my daughters knew
That one of those the prints recalled
Was still my love, would always be;
And did they hear my quick deep breath
Or see me flush, my eyes a'mist?

What did they think? What could I say?

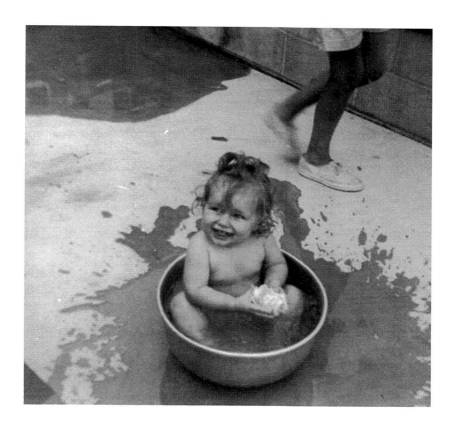

Said most about those meant the least
And tried to turn some pages fast,
Some that I could not talk about,
Some secrets kept no one will know
Except the one who's always known.

I hope my daughters too have kept
Albums that hold such memories.

MAN AND EARTH

We dig below the jungle growth
And sweep debris from cobbled streets,
Explore the temples and the tombs
Of those who came before…and left.
The earth survived and healed itself
Once self-destructed man was gone.
It will again.

So many times the cycle round
Like beavers move when food is gone;
And caterpillars propagate
Faster than the leaves will grow;
And when the bees that crowd a hive
Become a virus, fungus prey.
But earth survives.

Though man observes that coyotes leave
Before the last two rabbits caught,
We still pollute the ground and sea,
Destroy the sod that clutches dust
And cut the trees that make it rain,
Still kill our own in hate and war
Though suicide.

The deepest moats and sharpest swords
Nor tanks and planes and iron ships
Never were, will never be
Protection for humanity
Without the water, sod and trees,
Without the love of family.
When will we learn.

The ancient gods, retired now,

Who interfered for good or bad
With lives of mortals as they chose,
May watch below, be entertained,
As earth is scarred by waste of man
And mans success is his defeat.
The earth survives.

TRADING TALES

I never told my sons about
Some escapades of mine when young
(I'd worry if they did the same);
But now full grown, too old to scold,
Too late to add to my gray hairs,
We trade the secrets kept so long.
But never any talk of girls.

The time they cut the cattle fence
And let the sheep eat spinach, beans;
Then blamed it on a herd of deer;
Admitted that the broken pipe
That floated, drowned the baby chicks
Was not in fact an accident
But due to two when swinging high
As Tarzan did (more like the apes).
But never any talk of girls.

From time to time I've let them know
What happened on the freights I rode,
My summer spent in hobo camps
Between high school and college days;
And now I've learned the tracks in mud,
The broken bars and chopped down trees
Back of the field, across the ridge,
That I had thought by poachers made
Explained my dented pickup truck;
A war games tank with me away.
I'm sure to learn a good deal more.
They always seem to top my yarns;
But never any talk of girls.

PRISON

No shackles, chains
 Or bars about.
No chain link fence
 To hold me here.
The bonds attached
 Invisible,
But as in jail
 I cannot go.
So many times
 The Golden Rule
May hold the key
 Be jailor too.

TIME TO THINK

My mind is free while shelling beans
To search for truths, perhaps recall
Mistakes I've made that can't be changed,
To wonder why I'm here today,
Or if I am, or this a dream.

The thoughts I have of politics,
Solutions sure to solve all woes
With little knowledge of the facts,
I'll leave for others to proclaim
That they not me will look like fools.

So many times I've wondered why
That men would fight or nations war;
And never yet have reasoned why
That often those whose voices loud
Denouncing war, proclaiming peace,
Become the cause that they denounce.

From battlefields since time began
The honor for and glory earned
Could only be for those alive
And only those who won the war.
The dead are dead. They surely lost
Though fighting on the winning side.

If heaven be the final goal
Should men compete in guise of gods
To change another's route to go?
The truth is known, can only be,
To those now dead, if there be one
Or more than one or none at all.

These thoughts I have while shelling beans
Are often set aside it seems
To concentrate upon the dates
The salmon run begins and ends
And rabbit dogs will howl again.
Perhaps I need to plant more beans.

Did Socrates and Plato have
A lot more beans to shell than I?

REMINDERS

I chose this rainy day
　To drive for many miles
　　Along my lonely trail.
Alone between the trees
　That line the country roads
　　I'm free to see and think;
And as I pass the farms,
　The churches and the schools,
　　I dwell with memories.
Though still the scars remain
　The hurts I've had have healed,
　　Stay dormant in my mind;
While pleasures I have known
　Since just a little child
　　Come fresh and clear to mind.
Today I'll build upon
　Each happy memory
　　Recalled by what I pass,
Pick apples from a tree
　Beside a farmer's barn
　　And look for deer tracks there;
And when I pass a church,
　Its steeple tall and white,
　　Repeat a Psalm I know;
See children come from school,
　Recall "my girl", first love,
　　And stop beside a phone.

MAINE

Three rivers mark
 My route today
Across the State
 From west to east
And minor streams
 That had their share
Transporting logs
 From miles inland;
And long before
 They were the routes
For Indians
 In their canoes,
Explorers in
 Their poled bateaus.
I'll think of men
 Whose names appear
On monuments,
 In histories,
Who fought and lost,
 Who pioneered
The way in inland
 On routes I cross.

Have we done well
 For dreams they had
The future held
 For lakes and streams,
For moose and bear,
 For air and trees,
For mountain peaks
 And peace on earth?

BEANS

My father shelled these beans,
 Deep red with fine white stripes;
The same his father shelled.
 They planted, hoed, and picked
And saved the seed each year;
 Enough to plant next spring,
Whatever left, to eat
 With pork baked in a pot
For supper Saturdays
 And Sunday morning meals.

Now I am shelling beans
 My father gave to me.
I'm proud to grow them pure
 And save the seed each year.

Three generations shelled
 And saved the seed each year;
And it might well be more
 For no one seems to know
What generation first
 Had planted, raised, these beans.

Three generations but
 The beans so many more.

PAPER CASTLES

Beside the white birch trees
 Upon a maple limb
Where leaves were sprouting green,
 Black hornets built a nest
To hide what was inside.
 While back and forth they buzzed,
A paper castle built
 With one door underside.
Throughout the summer days
 I saw them come and go.
They did not notice me,
 Flew always out and back
From some place far away
 That was not known to me.

When leaves fell off the trees
 They left an empty house.
The winter storms piled snow
 Upon their paper roof,
And leafless branches swung
 Across their open door,
Tore off the paper walls,
 And now I see inside.

CATERPILLARS

I wondered why such awful things
As caterpillars had to be.
They eat the leaves from cherry trees
And hang by threads from naked limbs.
Those hairy, furry, squirming worms
Too often are unwelcome guests
At parties on the patio
And tables at a picnic spot.

But then a robin built a nest
High in a tree that I could see
When in my attic hide-away.
I watched the robins build their nest.
I saw four round and light blue eggs;
And sure enough, at last they hatched;
A furry pink and four big mouths
Forever wanting to be fed.
Then what did robin parents bring
That baby robins liked so well?
Those hairy, furry, squirming worms,
At least a dozen at a time.

SPARROW HAWK

I saw a sparrow hawk
 Perched in an apple tree
 Before the leaves came out
 Or grass was green in spring.
With sharp and curling beak
 And piercing eyes alert
 His looks might frighten one
 If it a larger bird.
Day after day he perched
 High in that apple tree
 And watched the field below
 For movement in the grass.
Then once I saw him fall
 With wings half spread to guide
 And claws outstretched to clutch
 The prey he'd waited for.
It was a little mouse
 Had made a meal that day
 For a hawk with patience
 Perched in an apple tree.

THE ROCK

They made the road around the rock
 Where moccasins had tread a path.
Three times higher than tallest man,
 Three times wider than ox was long,
The wise men knew a straight line through
 Was not as short as out around.
And so the road was changed from dirt,
 As years went by, to gravel pack,
And then in time was asphalt paved,
 And still it curved around the rock.

I was away a long, long time
 And came again back to the road
And where it turned out for the rock
 When I was here so long ago.
The road, now straight across a swamp
 On bridge with rails on either side,
No longer on the ridge I knew
 Held rock and road around, not through.
I found the rock after a search,
 Bending a trail where hikers walk.

MOTHERS KNIT

Tonight a full moon shines
 On deep and crusted snow.
The trees beside the road
 Cast broken shadows where
A wall is covered deep.
 And snow pushed up by plows.

The moon shines bright tonight
 Where gather boys and girls
To slide on hillside fields,
 And youthful voices ring
With cheer and happiness.
 To fill the chill night air.

The moonlight shines on homes
 Where yellow windows glow
From rooms inside tonight
 And mothers knit and wait
Until the children come
 From sliding on the crust.

THE BROOK

It's such a little stream
 And comes from underground.
It bubbles up from deep
 Within the mountain side;
More like a trickle here,
 Dammed by a leaf or two
To make a little pool,
 And then flow free again.

It gains in breadth and depth
 And music in its fall
From on the mountainside
 Before it slows to rest
Where beavers built a dam
 Along the valley floor.

UNCLE JOE

I loved my Uncle Joe
When I was nine years old,
"Tell us once again"
I'd plead in lantern light
Within our canvas tent
When rods were laid aside,
The hot dogs flamed and charred,
"Tell us one again
About the bear you trapped
And how he got away;
Show us the scars you have,
The claw marks on your back."

A hundred nights or more,
Before we doused the coals
We heard that lurid tale
And always asked for more.

"I can't recall your name"
Now ninety-one he says,
A quiver in his voice,
Each time I visit him.
Then in his great armchair,
His cane to emphasize,
"You won't believe it's true;
But now's the time to tell
Of how I trapped the bear,
The one that got away,
Left claw marks on my back
Are plain to see today"

I'll sit and hear again
That tale I've heard before

And hope someone sometime,
By list'ning once again
When I repeat once more
My story often told
Will help me to relive
What meant so much to me.

CHOCORUA'S CURSE

Still bare the ground
But ice creeps out
In sheltered coves
And flurries drift
On northeast winds,
The mountain top
Beyond the lake
Obscured by clouds.
Then suddenly
It opened up,
Though clouds below
The peak was clear.
A swirl of snow,
Or was it smoke,
Rose from the peak,
Took shape like from
Aladdin's lamp.
A genie there?
A giant one
With arms outspread
As if, I thought,
To bless or curse
The mountain side
And all about.
The only sound,
The howling wind;
And then all gone,
Obscured again
In dull gray clouds.

I do not know
If purpose was
To reinstate

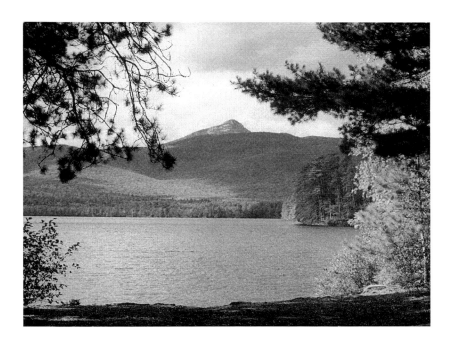

Or to forgive
The ancient curse
Made by the chief
Chocorua.
But it was there.
I plainly saw
Between the clouds,
Beyond the lake,
On top the peak,
The ghostlike form
That must have been
Chocorua

CIVILIZATION I

There's time and place
For spotted owls
And dinosaurs
When earth's concepts
Are measured in
The span of time
Of galaxies,
And life survives
That makes the change
Demanded by
The planet host.
Though brief or long
All time is short
When looking back
And what began
Will surely end.
This is the time
Of MAN on earth,
The time when brains
Devised the tools,
Facilities,
That feed and clothe,
Provide the needs
And pleasures too.
Could man survive
Catastrophe
From heat or cold,
Collision with
Another star,
Need to return
Compete with ants
If to survive?
Though sick or poor,

Though here and now,
Or thoughts in mind
Of camels and
The needles eye,
What means the most
For each of us
Is happiness.
So much of one's
True happiness
Is just reward
For what one does
For someone else;
A helping hand,
A sincere word,
True friendliness,
The cost of which
Too many find
A price too high.

SURVIVAL

So each defends
From enemies;
The porcupine
A thousand spears,
The turtle with
An armored shell,
The white striped skunk
With blinding scent,
The rattlesnake
A poison bite,
The weasel with
The speed of light,
The birds with flight
Above the trees.

Though all are prey
Survival of
Each species safe
Among its peers,
While man may make
All these extinct
It's only man
That man must fear.

ALL'S WELL INSIDE

It's cold and snow
 Blows wild around the house.
The cold steals in by doors
 And by the window sills
To chill the slippered feet
 Below the rocking chair.

Move closer to the stove.
 Put in another stick
From plenty in the box
 Piled high before the storm
By boys with coats and mitts
 When urged to do the chores.

Tonight the horses fed
 And cattle bedded down,
Kept warm between the mows,
 Let zero cold and snow
Blow all around the farm.
 All's well inside. All's well.

FARM CHECKLIST

The wind tonight enough
 To keep a man from sleep,
Though March and warmer now
 Than just a while ago.
It's near the winter end
 That carelessness can leave
A big barn door a'swing,
 Neglect to fasten tight.
Been warm like Spring today,
 First chance to air the barn,
Get rid of winter smells,
 The stuffy, muggy air.

The sheep, it's lambing time;
 That wind could bring some snow.
I'm sure I closed the door,
 Not sure I made it fast.
It's best that I get up,
 Put on some clothes, go out,
Make sure the door secure,
 No ewes about to lamb.
I might as well go now,
 Won't sleep until I do.

INSTANT RECALL

The snow came in with them
From angels in the snow
And fox and geese they said.
The chill within the house
In part from open doors,
The rest from melting snow
And drying out their clothes.
Their clothes were hardly dry
Before they dressed again,
Pulled hats and mittens on,
Went out to build igloos,
Then climb the hill with sleds;
But soon were at the door,
A jolly crown with friends
And brought the snow with them;
Hot chocolate this time
And cookies for them all,
Then out again for more.

It's in those quiet times
Before they all return
That I recall the storms
When I came through the door
To warm and dry myself
And sip the chocolate;
When I brought in the snow.

STONEWALLS AND MEN

The walls have stood since pioneers
Marked off their fields and cut the trees,
Then burned the stumps, dug out the rocks
And laid them up to mark their lines.
There's now no need for pasture fence
To keep the cattle from the corn;
The cattle and most buildings gone
And fallen stones are not replaced.
The wall itself remains in line.
It marks and maps the homestead farm;
And measures made of boundaries
Will measure same today as when
Recorded in the county books.

The old stonewalls tell us a lot
About the men and land they owned,
The cattle raised, the crops they grew.
The height and width of walls they built
Came from furrows turned in fields
While stones left in the fields, not moved,
May tell us much about the men
Their families, how hard they worked,
And if they loved the rocky land.

DAY OF REST

Not day of week; but weather made
 His day of rest from seasons work,
His day of rest except for chores,
 Though some would say in spring of year
To sons that pulled the weeds and hoed
 That rain could be a fishing day.
The chores the bane of farmers boys;
 The horses, cows and chickens fed,
The garden and the kitchen waste
 To hogs that wallowed in the mud.
If rain or shine at dawn and dusk
 One must be there nor miss a day,
The cows be milked, the eggs picked up.
 A rainy day his day of rest
From planting corn or cutting hay,
 For taking time to make repairs
On harnesses, to shoe a horse;
 But never, never leave the farm.
Be there to patch the pasture fence,
 Get cattle back from greener fields,
Keep wood stoves burning winter days,
 Be there in case of chimney fire.
His day of rest from seasons work,
 His day of rest....except for chores.

TO SPROUT POTATOES

An April day with snow.
It won't amount to much.
Though snow still in the woods,
The fields are bare and brown
And frost beneath is thawed.
Some robins have arrived
Perhaps a week too soon,
Four inches now or more
But dripping from the eaves
And sliding from the roof,
Will melt from trees and fields
In but a day or two.

To finish fence repairs
Can wait a day or two.
No need to go outside
When work's to do inside
And need of being done
On such a day as this.
I knew a week ago,
The winter somewhat warm,
The cellar not as cold,
I'd need a day inside
To sprout potatoes soon.

ABOUT AN OX

I thought another rock
To tangle tiller tines
And bent to pick it up,
To toss it on the pile
Outside the garden lot;
But flat it was and thin,
Or iron, not a stone.

Though pine I'd cut made logs
And stones and stumps removed
Proved many years had passed
Since this was cleared before,
It was an old ox shoe
That clanged on tiller tines
About a year ago
And now I'd found its mate.

The bent and rusty nails
Out near the forward tip
Must once had held the edge
Where blacksmith nailed to hoof
Was snagged by root, in mud,
Left buried in the soil.
By size I'd say the ox
Was small for working ox,
First shoes perhaps were lost
When being trained to yoke
And struggled in the field
Against both yoke and shoes,
Still learning gee and haw
From farmer's son with goad.

I'll keep this old ox shoe

And hang it near my desk
And often let it be
The cause to reminisce,
To dream about an ox
Whose shoe I found today.

FORECAST

It's just about to rain
　Along my lonely trail.
The clouds are closing in
　And all's in shadow now.
A farmer baling hay
　Leans forward on the wheel
As if to try to push
　The tractor faster now
And hopes to bale what's dry
　Before the wind and rain.
I saw a field with cows,
　Two dozen there or more,
All Holstein, black and white;
　Though scattered in the field
Each one was headed east,
　Each tail was swishing flies,
Each cow with its head down,
　Each one was eating grass.
And now the rain will fall
　To keep the warning made
By farmer, clouds and cows
　That rain would come today.

HARVEST

In fields between
Where leaves turn red
The corn is picked,
Potatoes dug.
The bins are filled
On cellar floors
Where cool and dark
The apples keep,
And carrots, beets,
With jars of fruit
On shelves beside.
Then when the frost
Has settled in,
The barren fields,
Are turned and brown,
There's tinge of smoke
From home cured ham
And salted cod
Will hang on pegs
Beside the stairs.

Let winter come;
If not enough
Of venison
There's pork and beans.

PROXY FISHERMAN

The lodge was warm inside
But hardy fishermen
Still cast their feathered flies
On pools where salmon lurked.
A cold wind blew in gusts
And tangled reels and lines,
Made whitecaps on the waves
Where rocks had changed the flow.

The lodge was warm inside
And he who tied the flies
For those who cast them now
And those who'd cast before,
A proxy fisherman
With cane beside his chair,
Now watched from warmth inside
The younger men outside.

The lodge was warm inside.
He saw a salmon hooked
And saw the fighting fish
Make runs that bent the rod.
Saw silver sides in jumps
To shake the tether loose,
Then brought to net at last,
He saw the fish released.

The lodge was warm inside.
In easy chair, with pipe,
His view across the porch
With empty rocking chairs
To where the river ran.
Was it the wind outside

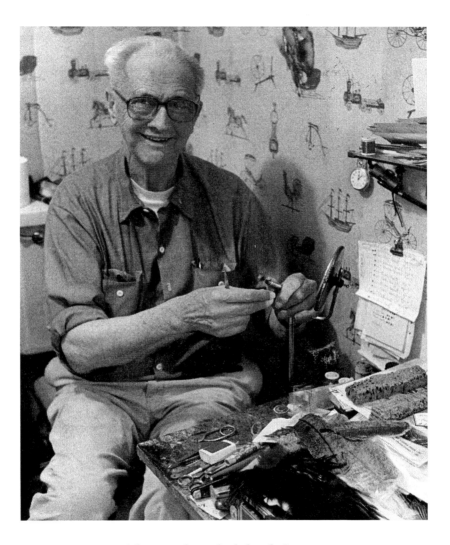

That gently rocked the chairs
Or ghosts of kindred souls
Who watched from rocking chairs?

ABOUT FISH

I'd swap TV and radio
And cars and planes and railroad trains,
Give up baseball and skis and skates,
And briefly apple pie,
For rod and reel and floating line
And days on end where salmon run
Up tumbling rivers from the sea.
I'd skip the class where math is taught,
The junior prom and senior ball,
Stand up my date a second time
To spend the hours with casting rod
Or trolling on a rippled pond.

There is no way that fish can know
How many lives they save each year
Of men who are so overworked
But take the time to wet a line,
How many marriages are saved
Because the man can get away
And give his wife rest for a while;
Or how much money can be saved
If spent on lines and rods and reels
Instead of a psychiatrist.

The patience learned by fishermen
From salmon, perch and trout
Helps raise a family of ten
Or more or less as children come,
Helps teach the children patience too.
So much we owe those little fish;
And that explains the reason why
When telling of our fishing trips
We may exaggerate the fish.

ROSES BY OTHER NAMES

I saw wild flowers bloom beside
The rawhide tents of Eskimos,
And saw a child with blooms clamped tight
In grimy hands that she had brought
To share the beauty with her Mom.

I saw my children pick the blooms
Of daisies and the dandelion,
The stems too short or long or none,
And bring them to the ones they loved.

Perhaps it's time I gave some thought
If one I know might like a rose.

WHY BUILD THE WALL

I sat to rest a bit
 From cutting down my trees.
The wood I cut today
 I will not burn this year.
No need to rush the job,
 There's time to look around.

A squirrel ran along
 Atop an old stonewall.
He hopped from stone to stone
 And chattered as he went
The wall a road as well
 As place to hide his nuts.

An oak had grown between
 And pushed two stones apart.
A squirrel long ago
 Who hid the acorns there
Forgot to mark the spot
 And so an acorn grew.

It toppled stones at times
 In middle of the wall
That once had rested high
 On larger ones below.
It took the place of stones
 That marked my boundary.

The oak about the size
 Of some I cut nearby.
The stumps of trees I cut
 Have sixty rings or more
And one had eighty-four;

The wall built there before.
I wonder who it was
　That built this old stonewall.
Who piled the stones on stones
　And made it straight and long,
Could balance awkward shapes
　And make a sturdy wall?

What tools could they have used
　To lift those heavy stones
And place them so they'd stay
　To mark what might have been
A neighbor's boundary
　Or just a pasture fence?

Why did they move the stones?
　Was it to clear a field
Or just to build a fence?
　Of course I'll never know.
I'll think on it a while
　Next time I sit to rest.

NATURE

From acorns dropped
A giant oak
Grew from but one.
The same be true
When burrs explode
On beechnut trees,
And seeds with wings,
Like butterflies,
Float to the ground
From maple trees.
A surplus crop
With dual use
Await their fate
On frozen ground.

The oak leaves fall
On top the snow
Where maple leaves
Are buried deep,
And those on beech
Still cling to limbs,
A blanket made
For seeds below.

The snow will hide
And deer will seek
The frosted nuts
That nest below.
Not all are found
By mice and deer
And trees from each
Will sprout and grow
When earth is warmed
By sun come spring.

TREE SALVAGE

The tracks I left in snow today
Went straight across the field and then
By edge of woods and entered there
Between the yarded piles of pulp.
By way of where I cut last fall
I came at last to this year's trees.
The needles brown on balsam fir
Attest to where the budworms chewed
And left the trees to smother, die.
I'll cut them now and sell for pulp.

Throughout the day the buzzing saw
Cuts down and trims and cuts to size;
And scattered wood awaits the spring
When all the snow has melted down
And wood can be brought out to pile.
A thousand steps and falling trees
Have trod and ground the snow and brush;
A thousand thoughts have filled the mind
As hours have passed this lonely day
And shadows marked the time to go.

Two steps I'll take while going out
Where I took one when going in.

A MARK STILL LEFT

I caught the scent before I saw
 The lilac blooms beside the wall.
It came as no surprise today;
 I took this lonely country road
With hopes of finding lilacs there,
 That they would stand beside the wall
And near a caved-in cellar hole
 That marked where once a house had stood.
While in a mood to dream a bit,
 I thought a place where long ago
A house had stood and folks had lived
 Might set the stage to reminisce
(No one was there to argue now
 If dreams should stray, get out of hand).
From crumbled walls where house had stood
 I found where shed had led to barn,
A barn the size to store the hay
 To winter feed a horse or two,
A dozen head of cattle too
 For milk and cream and cheese and meat.
I walked a lane between two walls
 And then beyond the pasture gate.
No grass, just trees, within the walls
 That fenced the pasture long ago.
Beside the lane where field had been
 And oxen may have pulled a plow,
Now pines grow tall and shade the soil;
 But mounds in rows like hills of corn
Still show the marks that men had made.
 Where they now rest I found the stones
With names and dates of births and deaths
 Who fed the cattle, worked the fields;
Some who had lived for many years

And some too young for more than tears.
Will someone some day stop beside
A garden wall or with a book
And think about a mark I left
When I was there so long ago?

CIVILIZATION II

The chickadees may hide their nests
And bobcats prowl in search of grouse
Where trees grow tall but chainsaws howl,
Provide the logs, by rugged men
Be moved with skidders, logging trucks,
And chipped and blown in paper mills,
Then soaked and cooked in acid broth,
Be matted, dried and rolled and sold
And hung behind the bathroom door.

THE LEAVES AND YEARS

I'll take a picture here, I thought,
Where red and green and gold reflect
From mirror surface of a pond
By moving just a step or two
I can include a slim white birch
And skeleton of old dead oak.
Just then I felt a gentle breeze.
The colors danced on tiny waves,
The red and green and gold of leaves,
The birch bark white and gray of oak
As in a huge kaleidoscope.

So many times in years gone by,
Before the ancient oak had died,
The birch matured and bark was white,
Before the beavers dammed the stream
I stood nearby or on the spot
And marveled at the scene in fall.
I kept the pictures taken there,
Recorded changes year to year;
And now like all the years before,
This year most beautiful of all.

Is beauty gained as trees mature;
Do I appreciate them more?

FALLEN LEAVES

The lawns are orange, red
And some a yellow hue
Where children play in leaves
That maples now have shed.
Though not the summer sun
And longer shadows fall
Enough is filtered through
The bare gray limbs above
To warm those playing there.

I know because I played
Among the golden leaves
Beneath the maple trees
When I was five years old.
I gathered piles of them.
I ran and jumped on them
And crawled beneath and hid,
Then scattered them again.
I felt the warmth of sun
In place of summer shade
And those were happy days.

THE MARKER

The red of woodbine leaves
 Now bright among the limbs
Of scraggly apple trees
 Bring beauty there again
Where apples once were picked
 For cider and for pies.
Now wormy fruit will feed
 The partridge and the deer
Beside the granite steps
 And caved in cellar hole.
The porcupines will sleep
 Where once potatoes stored
Beneath the arch of brick
 Where chimney stood erect.
The land too poor perhaps,
 A widowed bride who left;
Or did the building burn
 To end its usefulness?

For long the apple trees
 And lilacs in the spring
Have bloomed to mark the place
 Where once a home had stood.
Now woodbine in the fall
 Reminds the passersby,
And some may wonder why
 And who lived here and left.

HEAVEN

Could Heaven be more beautiful;
Than this October foliage
With blue of sky and green of grass,
A nearby tree of brilliant red,
Beyond a distant ridge aglow
That radiates a happiness
And brightens eyes and inner self,
A spear of bright red leaves
Above the pine and fir and spruce.
A hillside patch of yellow leaves
That mark a grove of sugar bush.

Is this the day I thought to be
Or truly Heaven here on earth?

No angels near. I'm still alone.
What name that river that I crossed?

PATCHWORK HILL

I think Grandmother got
The patterns for her patchwork quilts
From foliage she saw each fall
While washing dishes at the sink.
Through window there she must have seen
Across the meadow to the hill.
Bright red the maple skirts it wore,
A mix of sugar bush and ash above,
The bosom ringed with brown oak leaves
And like a patch, one small green field,
The crown of pointed spruce and fir.

That was the view that covered us
The long cold nights all winter through.

ONE PUMPKIN SEED

One pumpkin seed
 If planted now
May sprout to push
 Its roots below,
Its leaves above,
 The mother earth.
With sun and rain
 And nutrients
That it selects
 Form earth and air
(An orphan born,
 No mother hen)
It reaches out
 And covers ground.
In time mature
 Its yellow blooms
Entice the bees
 To fertilize.
The broad green leaves
 Stand high above
And hide the fruit
 That set and grow.
From just one seed
 Of dozens more
That grew within
 A pumpkin shell
(provided flesh
 For pies as well).
The vine it grew
 Has reproduced
Five hundred more…
 And Halloween.

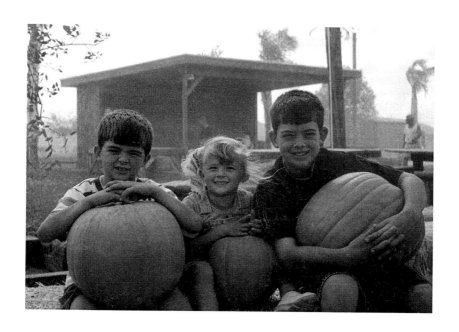

Such feats compare
 With those of men
Who fly in space,
 Walk on the moon.

GARDENER

I left my shoes outside
 But just inside the door
I heard her call to me,
 "Shoes off. I washed the floor. "

I brought fresh broccoli
 And put it in the sink;
She pointed then and said,
 "There's always worms inside."

And then, tomatoes ripe,
 More than a basket full,
And though we'd waited long
 "What WILL we do with them?"

Sometimes I wonder why
 Each spring it's hard to wait
To plant and hoe and sweat;
 But sure I always will.

MY GARDEN

My garden's more
Than soil and rocks
Cutworms and weeds,
Of beans to hoe
And corn to hill.
My garden's more
Than cukes and squash,
Corn on the cob,
Peas, tomatoes,
And broccoli.

It's growing plants
From dormant seeds,
The birth of spring
In soft, warm earth,
The buzz of bees
By scented blooms,
The robins' songs
And caw of crows.

A private place
In world its own
Where spirits rise,
Cares fall away.
Both sun and rain
Needed and blest,
Where watches stop.
Measure of time
Is dawn to dusk
And spring to fall.

TRICK OR TREAT

We left the porch light on
And hung the skeleton
Beside the kitchen door
That ghosts and goblins know
Where kindred spirits dwell
And pies and cakes are stored.

They came as owls and cats,
As witches with their brooms
And devils with their spears.
For many years they came
And always little folks
Sent in by mom outside.
"It's trick or treat" they yelled
As tiny hands pushed out
Through parting ghostly sheets
And devils dropped their spears
To cup their hand for more,
Then, "Guess, guess who I am".

Our guess was never right,
Not first or second guess,
"Why you in devil clothes
Are Johnny Bench, of course"
Then off the mask with squeals,
"No, no, I'm Sally Clark!"

An apple with popcorn
With nuts and fudge on top
Helped fill a paper bag.
With cake in hand and mouth
Their voices trailed away
Into the moonlit night.

All that was long ago.
Now goblins wait it seems
To frighten those who come
As angels and as ghosts.
The trick and treat reversed,
The devils camouflaged.

OCTOBER FARM

The cattle graze on greener fields
Where hay was cut and baled in June.

The chill has killed the nagging flies
And tails on each hang straight and limp.

Their hairy coats are shiny soft
And growing thicker day by day.

The fences straight that square the field
Mark where the corn was harvested.

The tractors, rakes and mowers stored,
The big barn doors are closed and locked.

A silo tall with rounded cap
Like a lighthouse dominates.

A time but brief to stop and rest,
For looking back, to plan ahead.

SUMMER PASSED

Where blush of blooms
Were so profuse
On apple trees
Last April days,
And scented air
Of life renewed,

The blushing fruit
Now ripening
Bend down the limbs
As if to break,
And sheds its own
Aroma there.

I planted seeds
In warm spring days
I tilled the soil;
And pulled the weeds.
I sprayed for bugs
And prayed for rain.

Now like the limbs
On apple trees
My back is strained
While picking beans,
Tomatoes and
While husking corn;

But sweet the taste
Of cucumbers,
Of succotash,
Corn on the cob,
And parsnip stew;
But time has passed.
It's fall again.

WINTER MOON

From here in bed
I cannot see
The winter moon.
Its light reflects
From fields of snow
And enters through
The window panes
In shafts of light
Across my bed.

I hear its call
To come outside
And crunch the snow
With booted feet,
To see smoke rise
Above the homes
Where stoves are stoked
And dry wood burns,
To see the flame
Of burning brush
Where children skate
Upon a pond.

I hear the call,
Would like to go;
But not alone.
I'd rather be
Alone and warm
Beneath my quilts
Than lonely cold
Beneath the moon.

OCTOBER

The fall wind clouds reflect
The brilliance of the setting sun
And set the western sky afire,
Then burning out to end the day.
More like a candle glow at night
The harvest moon creeps up from east,
Brings light enough that shadows fall
From stacks of stalks where corn was cut,
Perhaps from witches on their brooms.
The sights and sounds this night will bring
Are left for children to recite
In voices hushed, eyes like pies,
Beneath the sheets they wore to trick.

The sun will rise to frosted fields
And bales of hay still to be stored,
To smell of silage near the barn
And broken pumpkins on the road.

EACH HIS OWN

I stand and watch with awe
A man replace, rebuild
The carburetor from
My eighty-seven Dodge;
But know he never saw
A chicken pip and hatch.

I watched deft fingers touch
Computer numbered keys
And saw results in lights
Upon a silver screen;
And wondered if those hands
Had bathed a new born babe.

I flew in planes across
A sea and continent
Amazed in time and space
At what the crew had done.
Was sure not one of them
Knew how to milk a cow.

ECONOMICS

If there were doubt
 That we'd have snow
Those doubts by now
 Have been replaced
By what may be
 Too much of it.
We well might say
 That brown is out,
That white is in
 As skiers flee
The outlet malls
 And risk their bones
On steeper slopes;
 While doctors in
The hospitals
 Prepare the splints.

State road crews on
 The other hand,
Impatient too
 For overtime,
Will have a chance
 To earn the cash
And pay their bills
 For Christmas gifts
That were deferred
 On credit cards.

BONES

I'm sure that had the weather held
I'd not been sitting on the bench
Before a pile of puzzle bones
Upon the red checked tablecloth;
But when the January thaw
Had turned from rain to sleet and snow
I thought to cook a gourmet dish
A nearer meal than Burger King.
Assured we'd left in camp last fall
A good supply of frying food,
I opened wide the freezer door.
The cache of ice in rounded cubes
To chill a barrel of 'root' beer
Now filled most all the space inside.
A box of home packed broccoli,
A frosted unwrapped eel, I think,
And four potatoes hard as rocks
Were not the food I had in mind;
But then I found the chicken necks.
Though they like eels and broccoli
Keep longer in the freezer box
Than chicken breasts and steaks and chops,
They were my choice from what was there
To save a trip on icy roads.
The stew I made, a gourmet meal
With pasta boiled in cooking broth,
The neck meat added with the spice,
Well worth the time it took to pick
From off the bones and in between.

It was the puzzle of the bones
That held my fancy for a while.
Each joint of bone in shape and size

Not quite the same as those attached
Before I took the whole apart
And now without the muscle meat
No way to fit the way they were.
Like snowflakes, intricate design,
Beyond computer scope to solve;
But not unlike, except for size,
The bones within this neck of mine

TRUCK DRIVERS

Two trucks, big trucks, went past
At posted speeds at least.
Long silver boxes rolled
On eighteen wheels for each,
Tugged at my little car
While in their atmosphere.

I'd like to be, I thought,
A muscled brute of man
So I could drive a truck,
A great big truck like those,
Ride roads in all the states,
All drivers looking up,
Give way to let me pass.

I saw those trucks again
Parked at a coffee stop.
Two youths about to leave
The booth right next to mine,
A lean, lank boy, I'd say
Who might be twenty-five
A freckled girl with curls.

"We'll go first class tonight"
He said, "And celebrate
Our anniversary,
Not at just any place.
We'll find the best there is,
Another hundred miles
Will be enough today."

Outside I watched them climb
High steps on drivers' sides,

Mesh in the gears, take off'
In 'his' and 'hers' big trucks.
Those 'kids' on eighteen wheels!
I must be growing old.

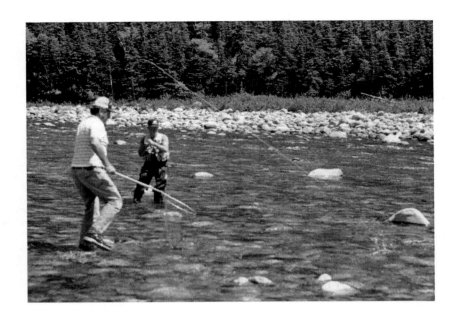

ATLANTIC SALMON

With rod in hand, boots in the stream,
My fly is cast again, again….
Not always where I thought it would,
Or leader tangled into knots.
But patience then, untangle them
And start with shorter line.
Too long it seems before a strike;
Sit on the bank and change the fly,
Then cast some more, change back again.
No luck today and day near end
With aching arm, cold tired feet,
About to quit, go back to camp;
And then the line is pulled away
Through fingers numb with wet and cold.
The reel alive and screaming now,
Unwinding line upon demand.
The rod tip up, instinctive now,
To power surge at end of line
And bend of rod to equalize.
The battle's on. Forgotten now
The tangled line, the aching arm.
The salmon jumps completely out
And splashing back, is off again,
Swims up the stream and deep below
And bends the line at waters edge.
If caught or not, it's here and now
This day was spent to talk about,
Relive in dreams, hope to repeat,
And keep always in memory.

LOST AT SEA

I saw the spray from ocean waves
Blown back across the beach again
And shoreline rocks though high above
Were drenched with salty waves that day.
The moon and tide and wind and rain
Conspired as one to show their strength
For all to see and hear and fear.
The masts bent back in troughs, on swells,
While weary men kept ships to sea;
And mothers, wives, and children too
Spent sleepless nights throughout the storm.
It seemed as if there were no end
To howling gale, the rain and hail;
That when it did and sea grew calm,
No ship nor bird could have survived.
But end it did. It always does.
It left its mark, a ship broke up,
Aground on rocks, the sailors lost.

In saddened homes nearby that coast
Were empty chairs where each had sat,
Said grace each night before the meal,
Left lonely hearts with memories.

The waves in time moved wreck to sea,
Wore scars from rocks where ship had struck.
The gulls returned from trees inland
And followed fishing boats once more.

I came again when years had passed,
Not sure I found the cruel rocks
Where long ago a ship had crashed,
Found no one there who'd lost a son

Who went to sea, nor knew a ship
And all aboard were lost nearby.
I found the stones that marked the graves,
Now overgrown with trees and vines,
Of men and boys, some in their teens,
With sailing ships engraved above
And "Lost at Sea" below their names.

CITY FARM

'Your wife has called; the pigs are out,'
The message read when I returned
From taking money to the bank.
Though no surprise and nothing new,
It always seemed the pigs got out
Just when the boss entrusted me
To keep the store on his day off;
Now thinking back, perhaps the boss
More tolerant than was my wife.
With six to feed and farmer raised
I thought to grow the ham and eggs
A way to better meals for us.
The rented house with carriage shed
That once had been at edge of town,
Though still with lot for garden space,
Had recently become but one
Of many more along the street.
The carriage shed our chicken coop;
And neighbors bought the surplus eggs.
With babies still in diapers
My wife objected loud and clear
To feeding hens and picking eggs,
To watching pigs that roamed the streets
Until her call could bring me home.
The marriage held though tense at times
In spite of pigs and cackling hens.
We sold the eggs and kept the pigs
Until the night I caught the skunk.
I'd known for days that some animal
Was scrounging grain and eating eggs
And bought a trap to catch the thief.
The varmint caught before the dawn,
A neighbor's dog, intent to help,

Mistook the colors for a cat;
And his retreat with anguished howls
Was but the start to loud protest
From neighbors and my family.
Before the stench had cleared away
And zoning laws put in effect,
The hens and pigs and clothes I wore
Releasing what the trap had caught
Had left the place, not to return.
So many times I heard those words:
'I told you so; I told you so.'

INFIDEL

A cloud of leaves
Blew off the trees

And swirling like
Blackbirds in flight

Swooped down the road,
Skipped on the wall,

Across a field
And disappeared.

All summer long
The wind had teased

And flattered leaves
To flutter, flirt

Until today
They went away;

But faithless wind
Will drop them off,

Take new playmates
When snowflakes fall.

FIRST LOVE II

The country roads of sand or mud
With canopies of maple shade
Have gone the way of dinosaurs.
So have the carriages with fringe
And sorrel mares that pulled the rigs.
The party done, the reins hung loose,
No need to guide if headed home.
The night, the moon, just two alone
And all of this so long ago.

I was not there. I heard it all,
Watched dreamy eyes, when Gramma told
Of her first love when she was young.

LIFETIME

Not knowing what
To say or do

You nestled in
My arms and heart
When we were very young

Though you escaped
The hold I held
My heart still kept your love
Through many years
Of memories

We are again
As when we met

LETTERS

Somewhere
The smoky remains
Of your written words
Swirl
In a tornado
Over burning desert sands
Or fall
To be frozen
In glacial ice
But remain
In my memory
Two blushing heartbeats.
 I was there
 You were there
 We were there
The memories
Stamped in time
That fire does not erase.
How wonderful
The memories
We share.

MY LOVE

How long the days apart
How many thoughts of you
But when we meet again
Then all my dreams come true

There is not time to think
Of things that might have been
The happiness we have
Fills minds and hearts in full

In the middle of my dream
Did you hear me speak your name?
When on my lonely trail
Did you hear me call to you?
When in a crowded room
Did you hear my whispered words?
How can you always be
Within my heart but free?

I must take time to watch the sun
Set in a cloudy sky
And I must find a hill
With view from east and west
And build a cabin there
While I'm still here to see sunsets
And blood still tingles from deep breaths
When seeing stars that fill the sky
And thunderheads and ocean spray

This world is mine
For just a little while
I shared its time
With friendly folks

And others too'
And with the trees

And ants and bees
Sunshine and rain
Will leave it lovely still
For my children
And their friends
To know and love
As much as I

WITH LOVE II

As long as I can pause
Beside a clover patch
And look for what some say
Will bring good luck to me,

As long as I can walk
Among the forest trees
And stand in awe by one
My arms won't reach around,

As long as I can see
The mighty ocean tides
And hear the roaring waves
Crash on a rocky shore,

As long as I can watch
A sunset in the west
Reflect its hues on clouds
Before the darkness comes,

As long as I'm alive
I want to share with you
All these and other things
That mean so much to me.

LIFE AND LOVE

Among the memories
That time can never dim,
The ones we can't forget
Are times of happiness
Because we were in love.
Though brief at times when hands
Were clasped, or lips were pressed,
Or love expressed in words,
By touch and sweet embrace,
The love so strong, so deep,
Its tendrils grew to reach
Each cell of mind and heart
To never be erased.

MY ONLY VALENTINE

If Valentines recall
 The happy memories
And cause romance to bloom
 Through many seasons past,
Then you have always been
 My only Valentine.

If Valentines have smiles
 That cheer a lonely heart,
Have arms that bring me close
 And greets me with a kiss,
Then no one else can be
 My only Valentine.

If Valentines have eyes
 That see the love in mine,
Respond with love for me
 Each moment I'm with you
Then you will always be
My only Valentine.

WITH LOVE

Will someone write for me
A lullaby to soothe
The baby in my arms
With words my son of six
Will learn to sing with me?

Will someone write a poem
In words she'll understand
Of love and sweet romance
That I would like to give
To daughter Ann now twelve?

Will someone write a poem
My son will memorize
And when he's twenty-one
Repeat those words to woo
The girl he wants to wed?

CURLS

I remember you
 When just a little girl
 With long brown curls each side
 Your impish, dimpled cheeks
 When first you came to school.

I remember you
 When you were in your teens.
 You wore a sweater, white,
 And knit from virgin wool
 By one of many friends.

I remember you
 So many times in church,
 I heard your voice in songs
 And kissed you there the day
 You got my wedding ring.

I remember you
 With children in our home,
 Their curls you fashioned then.
 How proud you were of them.
 How little time we had.

MOTHER LOVE

So carefully, so tenderly,
To wipe a tiny, runny nose,
To press a rosy, tear wet cheek
Against her own, and gently hold
A fevered little body close,
To say or sing in words content
That help relax, perhaps bring sleep,
Be there again when cough awakes
With cool, wet cloth on hands and face,
A glass with something cold to drink.

So many times when tears will come
Though day or night it's always there;
A baby's need, a mother's love,
So precious both to give, receive.

I REMEMBER

I do remember you.
You died so long ago.
You died so very young.
You did not want to die.
You tried so hard to live;
But it was not to be.

I do remember you.
Our daughters look like you,
Like you did years ago
Before you married me,
Before our sons were born,
When youth was all we had.

Yes, I remember you,
And I will not forget
The young and happy years
Before we thought of death.

ALWAYS YOUNG

I'm grateful for the memory
That keeps you always as you were
With no gray hair no wrinkled face,
And happy with our children near.

So long ago you went away.
Each one of us would not admit
The sorrow and the hurt he felt
For fear of hurting others more.

The place you left was never filled.
An empty chair, some words not said.
No answer for a question asked
That only you had answer for.

There'll always be the empty place
In minds and hearts of those you left.
There'll always be the memory
Of one so happy and so young.

OF BREAD AND WINE

I have no etchings there
To lure you to my den,
No fancy statuettes,
Nor books with foreign stamps,
No cat, no haunted house,
No excuse to romance.

But deep into my woods
Along a lonely trail,
There stands a giant pine.
We'll walk on mossy rocks,
Be brushed by boughs of fir,
And cross a tiny stream,
Before we reach the knoll
Where stands the giant pine.

There's music from the breeze
Among its lofty limbs
And songs of birds nearby.
The knoll is blanket soft
From years of shedding spills,
Now do you think romance?

This is my jug of wine,
My loaf of bread, and thou.

HAPPINESS

What goals have we set in our quest
For happiness while on this earth?
What brings us peace and happiness
To feel the beauty of the day
If fields of snow or green of grass,
In bright sunshine or cloudy skies
To murmur of the breeze in pines
Or stiff the breeze in sails above?

It's not the season makes the day,
Not rain or snow or cloudless skies.
It's what is deep inside of one
That spurs a choice that can be reached,
Recalls but happy memories,
Can share such thoughts with someone dear.

Let me live long enough to learn
That only I can change the day;
Because it but reflects the me
That I project from deep inside.

9-13
LOOKING BACK

Another year is history
Along my lonely trail again
And looking back I realize
How much I learned when just a child
Has influenced my words, my deeds,
For each of more than eighty years.
The quiet words my grandma spoke,
The Reprimands my father gave,
Each in its way identified
The good and bad, the one to choose;
And to this day the Golden Rule
That grandma taught will come to mind
When I'm inclined to favor self,
The sting of stick, if I have lied.

I wonder if I'd been denied
The time that grandma spent with me.
The promised spank in punishment
For words or deeds I'd trespassed with...
I wonder if, on looking back,
There'd be so much to thank them for.

AURORA HEATH

The river crawls
As would a snake
From beaver dam
To beaver dam
And side to side
The grassy heath.
Between its banks
Of water bush
The otters play
And fishes swim.
The turtles sun
On rotting logs;
And ducklings hatch
In down lined nests
On grassy mounds,
Close to the stream.
Though eagles soar
And coyotes stalk
Species survive
The predator;
And when the moose
Return in spring
For lily pads
The dams and fish
And predators
Will all be there.

THEN CAME THE RAIN

I saw the clouds
Low in the west.
I saw the sun
Go down behind
And leave the day
Before its end;
But long the spell
Without some rain
And clouds before
Brought only wind.
Dust blew across
The fields and roads,
And garden weeds
Wilt from the heat.
And clouds again
That hid the sun
It seemed would bring
More wind, not rain.

And so it was
A big surprise
When I awoke
And heard the rain
Upon the roof,
Drip from the leaves.
Then with the dawn
Saw leaves on trees
Shake off the drops
That washed them clean.

O Happy Day
That brought this rain
To lay the dust,

To quench the thirst,
To bathe the trees
And fill the streams.

O Happy Day
That brought this rain!

TOMORROW

Though long the way that lies ahead
 The miles are short that have been tread
And time ahead though less each day
 Holds promises lost in yesterdays.
Our memories, though sacred thoughts,
 May still remind what might have been
And minutes past can never be
 Brought back except in pantomime.
The scars from burns and broken bones
 Because we tripped and fell at times
Each narrowed down the risks we take
 For fear the hurt not worth the odds.
Each life renews the pattern set
 By those who made their tracks before,
Each learns by burns and broken bones
 A way of life between the hurts
And keeps among the memories
 Only those one wants to keep.
It's not ones age in later years
 Nor what has passed before this day
That makes this life worth living out;
 It's what one thinks there is ahead
That soon will pass, that too be gone,
 And justifies each day to end.

THE RAINBOW

The shower clouds were blowing low
 Between the hills along the way.
So dull a day to drive, I thought,
 Now end of fall, no leaves at all.
But then behind, a burst of light,
 A break in clouds; The sun came out
And just ahead its magic struck
 A rainbow arched across the sky,
Marked pot of gold in road ahead.
 A car ahead drove through
(As if it were a ghost)
 But when I reached the spot
The rainbow went before,
 Across a lake, against a mountainside,
So bright there was a second one
 Reflected on the clouds above.
For long I chased the rainbow ends
 By way of twisting, turning road,
Tried hard to pass beneath the arch,
 But when it seemed I'd reached the place
Where pot of gold was by the end
 It slipped away, was somewhere else
Or faded momentarily
 But always to return again;
The spectrum in its truest hues,
 Each color in its proper place.
And then I came to rain again,
 A rain that washed it all away.

FALL

Did you see the geese;
An arrow headed south
Against the fluffy clouds
And blue of sky above?

Did you hear them talk;
Uninterrupted talk
As they discussed their route
Or squawked of guns below?

Did you notice when
The sight and sound had passed
A chill north wind arose
With snow in flurry flakes?

LILACS

Now lilacs bloom
 And mark the land
Where homes once stood
 By lonely roads.

The cellar holes
 And granite steps
Now overgrown
 With grass and trees.

Might not be seen
 Except in June
When lilacs bloom
 And make one look.

How long ago
 That someone with
A love of blooms
 Set lilacs there.

That "someone's" gone
 And buildings too
But lilacs still
 Bloom there in June

SHADOWS

I saw the puffball clouds
Above the mountain tops
Below a deep blue sky.
I watched their shadows crawl
Across an iron bridge,
Held up by waving grass
And leaves on willow trees.
When one came after me
I tried to run away.
It caught me in a field
And hid the sun from me.
It seemed to swallow me
As if I'd dived below
The surface of a lake
But still could breathe fresh air
And felt no weight or wet.
My shadow disappeared,
Absorbed in greater strength.
The breeze was cooler then
Without the sunlight heat.
Though tucked in tighter than
A blanket round a babe,
I did not feel its touch
From when the shadow came
Until the shadow left.

THE RAIN AND EARTH

There's been no rain for weeks.
The plants and trees survive
By wilting in the sun
And shrink to minimize
The water loss to air,
Where farmers work in fields,
Prepare to plant their seeds,
They raise great clouds of dust,
Pollute the summer air.
The trout that swam upstream
When brooks were running high
In spring from melt of snow
Return to pools and lakes,
To water deep and cool.

Somewhere on earth of course,
Perhaps not far away,
The quirks of Nature brought
Day after day of rain,
Too wet to farm the land,
Roads washed away in floods.

But now the jet stream turns
And brings the storms this way.
While dark the day with clouds
From which the raindrops fall
The leaves on plants and trees
Uncurl to breathe and bathe.
The clouds of dust dissolve,
Their nutrients returned,
A part of earth again.
The rain and earth as one
Like lovers met again
Have been too long apart.

OCTOBER VIEWS

Fair weather clouds
Of many shapes
Are cotton white
Against the blue
October sky.
The bursts of red
In maple swamps
Foretell the frost
Of chilly nights.
The woodbine leaves
On winding vines
Trim roadside walls
And apple trees
With brightest red.
The grass is green
Where cattle graze
In fields between
The fresh turned earth
Where corn was cut.
Beyond the trees,
Against the sky,
A mountain peak
Is white with snow.

MORE LIKE A STUMP

He stood beside the road,
Straight up, more like a stump
Than flesh and blood and hair.
When I came close I saw
His eyes as he watched me
Without a single blink.

When I was safely past
I slowed the car to watch,
And looking back I saw
He almost disappeared,
Went back to hunting greens
In stands of old dead grass.

So many times each meal
That woodchuck turns to stump,
To watch without a blink,
As cars slow down and pass!
He'll store his food in fat,
Next winter hibernate.

OF MEN AND DAMS

Not far beyond but out of sight
Of those who pass along that road,
I saw a wall of rough-cut stone.
I'd not have seen the stones at all
When leaves were thick upon the trees
Or winter snow had covered them;
But now in spring with trees in bud
When walking by they caught my eye.
I followed close beside the stream,
But culvert size beneath the road,
And came to where the stones were placed.
Though tumbled now by time and floods
The stones were placed to build a dam.

Before the power came in wires,
Before the engines turned the wheels,
The grain was ground in spring of year
And logs were sawed by power from
The little pond of water stored
Behind this dam of rough-cut stone.
The neighbors came from near and far,
In wagons with their bags of grain
And loads of logs by oxen drawn,
Each customer a partner too
In bagging meal and rolling logs.
The time so brief in spring of year
When April rains and melting snow
Would turn the saw and grinding stone.

Now once again the beavers came,.
Rebuilt the dam with sticks and mud;
Except the stones placed there by men,
About the same before men came.

ALBUMS

What brings to mind this winter day,
　Too cold and stormy out of doors
　　For work that later can be done;
What brings to mind on such a day
　The times and friends and things we did
　　When we were young long years ago?
What brings to mind a horse named Dan,
　A curved dash sleigh and sound of bells,
　　And country roads from farm to town?
What brings to mind when wind was east
　The mournful sound that fog horns made,
　　The toots of trains when wind was west?
What brings to mind the one room school,
　The long wood stove and water pail,
　　The morning prayer, salute to flag?
What brings to mind the faces, names,
　The clothes they wore, of boys and girls
　　With whom we played when we were young?
What brings to mind the shouts and laughs
　While wood was burned on frozen ponds
　　To furnish light and warmth if cold?
What brings to mind the happiness
　Of holding hands, of shining eyes,
　　Of first love's scary goodnight kiss?

Its brought to mind because today
　I turned the pages one by one
　　Of dusty albums, now so old.

THE BARN STILL STANDS

The barn where I trod hay
So many summer days,
So long ago, still stands.
The sides no longer straight
Beneath a sagging roof,
The big doors boarded up.
For long a busy place
With storing hay in mows,
The stalls where horses stood,
The pen for calves, tie-up
Where cows were milked and fed
And bantams scratched for grains.;
The frost built up around
The tie-up window cracks
In spells of winter cold
Resulting from the warmth,
And moisture from the cows
Within, well fed, content.
The barn (the house long gone)
For just another farm
Along that rural road,
Not near enough the next
To see on summer days
But not too far for friends.
So many years it stood
With shingled sides and roof,
Then near to always straight,
So much a part of all,
So much like all the rest
Along that gravel road.

There is no beauty left
To sagging, broken beams,

The shingles mouldy now;
A rotting barn that stands
 Among new houses where
 Once pasture grass was grazed.
It's so much out of place
 Where once so much a part
 But still holds memories.

RENEWAL

The hills are shedding snow
 From warmth of summer sun,
The trails on mountainsides
 Without a skier now.
The bumps in roads remind
 The earth is thawing out.
Though view the same last fall,
 When first the mountains white,
As last to melt in spring,
 What change in those who see.

As we shall greet the dawn
 So much unlike sunset.
So we shall greet each spring
 So much unlike the fall.
The planting of the seeds
 Not like the harvesting.
The budding of the leaves
 Make moods unlike when they,
Though brightly colored fall
 To leave but skeletons.

The thoughts that fill our minds
 When geese fly south in fall
Unlike the thoughts we have
 When they return in spring.
The bear that hibernates
 With winter food in fat
Awakes to hunger with
 Her cubs in early spring;
Her attitude somewhat
 Unlike before she slept.

The farmer in the fall,
 His harvest great or small,
Must rest with what he has;
 But spring will bring no end
To furrows he will plow,
 To dreams that he will have.
And always in the spring
 True love is born anew
Along with birds return
 And yellow daffodils.

WINTER WALK

You'll need your boots today,
 The insulated ones,
And woolen mittens too.
 And winter's here again
At zero or below
 And with the way the wind
Is blowing with the snow
 We'll have to move along
To keep our warmth within,
 Watch out for frosted cheeks.
We'll walk on frozen snow
 Across the open field
And up the wooded hill.
 No wind to chill the cheeks
While we're among the trees,
 Just smell of spruce and fir.
We'll not stop long on top;
 It's cold and windy there,
Just long enough to see
 The white capped mountain peaks.
There's beauty all around;
 The frozen lakes and streams,
The hills with hardwood trees,
 Their shadows on the snow;
And by the lakes and streams
 The evergreen of pine.
The mountains are for trees.
 Each specie has its place.
Their roots hold loam and rocks
 High on the mountain sides.
Their limbs hold nests of birds
 And deer feed in their shade.
The more one looks about

More beauty's there to see
From here to peak afar;
A lifetime to describe.
But come we have to go;
The wind is biting through
Our insulated boots
And woolen mittens too.

WRINKLED ONES

Some days perhaps I'll be
 Like folks I've seen today.
With measured steps they walk,
 Some straight, some slightly bent,
And some that lean on canes,
 For papers or the mail.
A dog may walk beside,
 Sometimes ahead, of men.
A little girl or boy
 May hold a woman's hand.
They greet each time they meet,
 Have time to talk about
The little child or dog,
 The winter passed or spring.
It's springs, not birthdays now,
 That count the years achieved,
How comforting the sun
 Of spring and summer days;
Drives out the winter chill
 From joints now sore and stiff,
Gives confidence of life
 And happiness ahead.

I'd like to stop and talk
 With some I've seen today,
To listen while they talk
 With sunshine at their backs.
It's not of men on moons
 Nor war in Lebanon
That I will hear them tell,
 Nor traffic deaths this year;
But what a grandchild writes
 From where her parents moved,

That though his dog was old,
　Was anxious for his walk.
But then another day,
　Not first the time I'd stopped,
I'd hear of younger days,
　Of love and work and play,
Of farms and city streets,
　Of dreams and tragedies.
I'd learn the reason for
　The wrinkles and the scars,
The twinkles in the eyes,
　Of some now bent and old.

BY THE BAY

Grandfather rowed each week
Across the bay for mail,
For yarn, tobacco and for
The things he could not grow
Or catch or shoot or make,
Two miles or more each way.
It took most all the day
With wind and tide at best.
He caught the flounder, cod,
Built walls to keep the cow
Outside the garden patch.
He found his pleasures there
In work he did each day,
Was happy, satisfied.

A blacktop road now leads
To old stone walls he built.
The R.F.D. brings mail
To right beside my lawn.
The mall two miles from there,
An hours trip at most
For all the things I need,
Things that grandfather made
Or whittled, caught or shot.
The many things he did
Now someone does for me,
And yet I wonder if
I find the happiness
In long vacation weeks,
Weekends and holidays,
That he experienced
While rowing with the tide
And building walls of stone.

FROM MELTING SNOW

Though but a little waterfall
And close beside the road, in fact
It's fall was from the bank above
To rocky ditch that drained the road,
I'd think three feet or so.
What's more, since it was fed by snow,
When snow was gone, it too would fail.
But now in spring it was alive.
Between the roars of passing trucks
I heard the roar of waterfall
And saw the bubbles that it made
When pounding into pools below.
It did not seem to mind its flow
Had changed from what it might have been,
Now flowed in ditch beside the road.
It rippled over rocks and sand
A jolting melody of sorts,
Competing with the sounds nearby
When trucks and cars went speeding past.
Though brief its life in spring each year,
Like peepers in a roadside swamp,
I thought it was a happy sound.

Photograph by Natalie Peterson

WHAT DOES THE OCEAN SAY

What does the ocean say
In whispers on the sand?
Does it converse with trees
Whose answers seem to be
The wind among the leaves?
While just outside the cove
Waves roar in angry tones
And pound upon the rocks.
It sings a lullaby
By hulls of ships at sea
On warm and sunny days;
But with an east wind gale
Its howl intimidates
The bravest soul aboard.

No words as such are said
In English, French of Greek;
But like a baby's cry
For hunger, anger, fear,
There can be no mistake
For what the ocean says.

SNOW STORM

I felt the snow against my face
 Before I saw the tiny flakes.
Although since dawn the sky was gray
 The forecast snow had still to come.
Perhaps too cold until the sun
 Above the clouds had brought about
The chemistry of cold and heat
 To make the sparkling crystals fall;
And soon the air was dense with flakes
 Adrift to float and slowly fall
Until they rested on the ground
 Or held above on lacey limbs,
On shingled roofs and my red hat,
 Or caught behind a moving car
Went swirling after down the road
 And blocked the view for those behind.

I walked afar in fields and woods
 And saw the storm become intense.
A rising wind and larger flakes
 And inch by inch the depth increased.
The fields, the trees, the walls and stumps,
 The air, my clothing, all were white.
When deeper than my boots were high
 I turned, went back the way I came
Along the tracks that I had made
 Until they too were covered up.
When light was gone that stormy day
 I watched through frosty window panes
And saw a truck with flashing lights
 Plowing the snow to clear the roads.

THE STAR

Did you see the star
This cold December night?
Did you see the star,
Perhaps the star I saw
Above, ahead of me
Along my lonely trail?

Did you see the star
Though clouds seemed thick and low?
Did you see the star
Perhaps where clouds were thin
But always up ahead?

Did you see the star,
A bright and shiny light?
Did you see the star
That seemed to beckon me,
The star that guided me
One dark December night?

SNOW SILENCE

The silence of the falling snow
Comes through the cabin walls tonight.
The lack of sound seems ominous;
And even mice between the logs
Must feel the still. They make no squeaks.
No sound above my own heartbeat
Although I listen and I wait.
Perhaps a loaded branch will break;
Or snow will slide from evergreens
To make a soft and pillowed thump.
The wait tonight is not unlike
The wait in summer thunderstorms
Between the lightning flash and boom;
Except the silence longer now
And wonder what the sound will be.

Perhaps a hunter lost will knock,
Perhaps a coyote howl outside.
A soaring snowy owl may hoot,
Or porcupine may chew below.

If one or all these sounds were made
I did not know. I fell asleep.
I woke at dawn to see the snow
Piled high against the window panes.

GHOST

I've heard and read a ghost
Would make a sound like that,
Always in the night.
I can't describe it now
That daylight's here once more.
It seems more like a dream,
The scary memories,
Half hid in smoke and fog.

'Twas nothing that I saw.
One does not see at night;
And it might well be true
I kept my eyes shut tight.
Awake or in a dream,
A low pitched whistle sound;
Or was it high and shrill?
And then like sentence end,
A pop; like period;
But never quite the end.
A quiet time, suspense,
Almost without a pulse;
And then that whine again.

It was almost the same
As made by wind today
When blowing snow around
The corner of the house.

THE JONQUILS BLOOM

When all the leaves
 Are off the trees,
The wood is split
 And harvest in,
The squirrels hid
 The sweetest nuts,
The mother bears
 And masked raccoons
Have found their nests
 To hibernate,
When snow lies deep
 Upon the ice
On streams and lakes
 Where I have fished
And ravens, owls
 And chickadees
The only birds
 To stay around,
I hope and pray
 My larder's full
That I'll survive
 The winter through
And live to see
 The jonquils bloom.

IN SPRING

How good it is to hear
The thunder, see the flash
Of lightning and feel
The flood of rain in spring.

When apple blossoms spread
Aroma through the air
And bees buzz bloom to bloom
Through warm and sunny days.

To watch the silent flight
Of butterflies and moths
And see a trailing string
As swallows build a nest.

How soft and green the grass
Bent by a gently breeze
Across the farmer's field
To wall of stone behind.

THUNDER STORM

I saw the angry clouds
 Above my lonely trail.
They rallied with the wind,
 Sucked moisture from the earth,
Absorbed the heat from sun,
 Became great thunder heads
Their bellies, black, hung low
 Beneath the feather white
Of swirling mass above
 Until all merged in black.
Just then the Gods decreed
 The battle should begin.
The sounds but growls before
 And rumbles from afar
Became staccato booms
 That echoed from the hills;
Then light exploded in
 And rain came pelting from
The angry clashing clouds
 Above my lonely trail.

THE STORM

Wild howls the wind tonight;
Its tendrils grasp and tear
The frosted leaves from trees,

It steals the spray from waves.
It rocks the fishing boats
And stings the sailor's cheeks.

It carries freezing rain.
It whitens mountain tops,
Drives bears to hibernate.

It clamors to come in
At windows and the door,
Through cracks in roof and floor;

But sturdy trees, now logs,
That made this cabin strong,
Protect me well tonight.

And when the storm has passed
I'll fill the box with wood
Be ready for the next.

PATRIARCH

His world was all that he could see,
The fields, the trees, the house and barn,
The cattle, horse, and family.
His arms were brown from sweat and sun,
And muscles filled his faded shirt.
With reins around his neck, he called
The 'gee' and 'haw' commands. And held
The plow to keep the furrow straight.
He got his rest while milking cows,
Took grain each week to pastured stock

To count, and have them tame each fall.
In winter time, he cut his trees
With chopping ax and cross-cut saw.
He knew where flowers seldom seen
Grew wild. And knew their names,
Brought blossoms home in callused hands.
He dried strange herbs for medicine,
From golden thread to pokeweed roots,
Knew what they'd cure for man or beast.
His children learned his way of life
While pulling weeds and picking peas,
While cleaning stalls and catching fish,
And learned that Nature gives and takes.

He left the farm when slightly bent,
His last big horse too old to work,
The trees too tall, the ax too dull.
He left his land to younger men
With tractor plows and motored saws.
He planted seeds in flower beds,
Then gave away the blooms he picked,
And watched birds nest in apple trees.

His world became a little room,
Filled with distorted memories,
And squeezed each day to smaller space,
As sight was blurred and hearing failed.
His thin white arms and bony hands
Were cold to touch and trembled some.
His hair was thin. He slept a lot.
At ninety-two, his time had come.

He had respect and love for earth,
To which he gave the same he took.
He rests in peace. He left the world
A better place than when he came.

NOT TOLD

We have survived these many years,
Each in his private niche of life,
Each with so many memories
Of happy childhood, long school years,
Adventures of our bodies, minds,
Through puberty and then adults.
We must have known that we would age
When seeing parents turning gray.
They and their friends who passed away
Took long kept secrets of their loves,
Adventures, hurts and fears with them;
Some gripping novels no one wrote.

But all those years I never thought
The time would come when we'd be old,
The stories of our lives not told.

AXE HANDLES

I use my father's axe
To split my kindling wood.
A single blade and wide
He kept it razor sharp;
For years a special axe
He used for scarfing trees,
Prepare for crosscut saw
And guide the tree in fall.
While chopping maple, oak
And beech for city stoves
He watched for hornbeam trees
Of length and size without
A blemish, bend or knot
To carve axe handles from.
It seemed that quartered trunks
Through all the winter months
Were leaned against the bricks
Behind the big wood stove.
When dry enough to suit
My father traced the shape
Around a pattern made
From one that suited him
And roughed the handle shape
By trimming with an axe.
His pocket knife, a rasp,
An edge of broken glass
Were all the tools he used
A little while each night.
When supper cleared away,
The lamp at table edge
And then the light but dim,
He whittled, filed, and scraped
Until the trunk became

A handle for his axe.
I sometimes see a hornbeam tree
When cutting timber in my woods,
And though it's straight without a knot
I have no need, with motored saws,
For handles on a chopping axe.
The one I have my father made
And holds the axe that he once used
I'll use to split my kindling wood.

LET WHISKERS GROW

I hear the rain upon the roof
And wind in trees outside the walls.
The cabin is a quiet place
Or sounds like these could not be heard.
The only other sound I hear
Is crackle of the burning wood
That keeps the room so snug and warm.
Sometimes one needs a place like this,
A place to let one's whiskers grow,
To hang a rod upon the wall
Or keep a gun on antler rack,
A place to rest a weary mind
With memories of days long gone,
To build again with sons and friends
A cabin in the wilderness.
Though some may never come again
They all return in memories
When raindrops fall upon the roof
And wind blows limbs against the walls.

DECISION

I want to stay
This rare December day,
To stay with wood smoke smell

Inside, outside, the camp,
Be here when suddenly
The warming summer breeze
Is blown away by snow
And rabbit tracks abound
Beside the cabin door.

Why can't I stay?
The cabin's snug, kept warm
By burning maple wood,
From pile I'd cut and split
For long enough do dry
And safely stored away.
The cold, deep spring won't freeze,
Just steps beyond the door.

But I must go.
The reason's not what's here,
Not water, weather, food;
Not fear the wilderness
Nor even loneliness.
It's what I left behind;
Responsibilities of mine and mine alone
And promises I made.

THE TIME AND PLACE

This is the day
To run away
To leave behind
The angry thoughts
And dearest friends
That spoken words
Be sure to hurt,
Words said in haste
And born of stress,
Anxiety,
Perhaps some pain
Not physical,
But deep inside
The heart can't solve.

I'll find a way
When all alone
Where wood stove smoke
And tree blown sounds
Relax my mind,
Help me to see
That others need,
No less than I,
A time and place
That's theirs alone.

KEEPSAKE LEAVES

I've seen the yellow, gold and brown
Of leaves along my lonely trail.
I've seen the maple leaves turn red
From tinge of frost October nights.
The leaves about to fall to earth;
The trees about to hibernate.
For years that fade in memory
Some trees it seems grew old with me.
I saw their flaming leaves on sprouts
When driving by in Model "T."
I with my love would stop and pluck
A giant leaf of brilliant red,
Now keepsakes pressed inside a book.
The trees grew taller year by year.
A thousand leaves were brilliant red.
Held high by me, my children reached
And plucked the leaves for their scrapbooks.
One tree still grows around a bend.
Today I stopped and left the car
Some distance back so I could see
All eighty feet, the whole expanse,
The red announcing seasons change.
Beneath the tree, from fallen leaves,
I chose but one of brilliant red,
Another keepsake for my love.

CHIMNEY FIRE

They always burned on stormy days
When wind blew like a hurricane
And on the coldest winter day.

The acrid smell, the thunderous roar,
The smoke and ash erupting from
The chimney top, sometimes the flames;
Its shadow on the fairest days,
Its frightening light at night,
The fear of danger to the house.

The somber faces all about,
The sobs of children feeling fear,
Dressed hurriedly but kept inside.
The stove now cold, and open doors,

The men first in then back outside
To listen near and feel for heat
Behind the stove, by closet walls.
Place ladders to, up on the roof,
Watch out for sparks that might ignite
The shingled roofs of house or barn.

The neighbors up and down the road
Have seen the smoke and spread the word,
Bring blankets, buckets, ladders, axe,
The comfort felt from friends around.

Not nearly long as it had seemed
The smoke subsides, the fire out.
The doors are closed, the stove gives heat
And folks who've come will sit awhile,
Recall some other chimney fires,
And some that burned a neighbor's house.

WHAT WAS THEN

I drove on once familiar roads,
On village streets, by shaded lawns.
So many things have changed.
Split level homes replace the barns
Where hay was stored when I was there;
And ranch style homes now skirt the field
Where grass was mowed and cattle grazed.

Some young folks lurked beneath the signs
Displaying coke and lotteries,
Teenagers smoking cigarettes,
Time on their hands, nothing to do.
No lawn to mow? No beans to hoe?
No fence to paint? No berries ripe?

The sandy road that slowed my bike
Is now an asphalt thoroughfare.
The trees where buckets hung in spring
No longer there providing shade.

Did I leave so long ago?
Such changes take so many years.
Would I know one who might have stayed?
Would she know me or I know her
Or strangers be if we should meet?
Until alone and then review
The memories; but not compare
What is today with what was then
Nor many things that might have been.

R.F.D.

I knew that spring had come.
The frost was out the ground
And no more snow would fall.
It happened every year;
A sign that never failed,
Dependable as death.
I took that country road
In hopes the time had come
To see him at his task.
I slowed to round the bend
Before his yard in view
And saw the bent old man,
An iron bar, a spade
And fresh hewn cedar post
With hammer and some nails
Still on his wheelbarrow...
A relic made of wood
That once his father used.

His beard was shaven clean;
Its winter need now passed.
The box he held, though bent,
He'd bend it back again
To hold his U.S. mail
Replace the broken post,
Set back a bit this year
In hopes the snowplow blade
Might bury it and miss
When plowing snow next year.
I doubt his thoughts to curse
The driver of the plow.
Like airing out the barn,
Take banking from the house.

When peeper frogs are heard
It's time again to fix
The mailbox by the road
So all will know…it's spring.

RECONNAISANCE

What did I want from life on earth?
How could I know, not knowing where
The road I took could lead, did lead,
Whose other lives helped shape my own
Because of love or fear or chance.
And what of dreams that seem so real
When morning brings the memory of
Another place, another time,
Perhaps another life I share.

What did I want from life on earth?
What did I take? What will I leave?
I am the only one who knows
But not the only one to judge.

Of all the things I leave behind,
My fishing rod and walking stick,
A pencil, pen, a pad with notes,
The books I've read and some I've not.
There's nothing but the memories
That I can neither leave nor take.

The land and trees were never mine;
They both entrusted to my care
As was the soil I planted in.
And what of time, a part of which
Between its start and end I shared?
It never stops. It has no 'now'
Until it's past, then can't be 'now'.

If just in case I might return
To earth sometime, I pray let me
Behave while here in such a way

That I'll be welcome back on earth;
And not alone by human life
But to include all living things;
The grass and trees and bees and birds
And night and day, the sun and rain.
Just let me grow from birth again
Through all of my allotted years,
To be a child, to love, be loved,
To read, to write, to do and think,
Appreciate and to respect.

STORIES TO TELL

The road's not smooth,
Still lots of curves
Not yet improved
For increased speed
Though now all paved.
Phone wires on poles
Fence out the trees
One side the road,
Connect the lakes
To Washington
And Hollywood.

The cabin's built
Of cedar logs
With dirt packed floor,
Then candle lit
If lights at all,
With wood smoke smell
And fir packed bunks;
Where memories
And stories told
By gray old men.

The poachers then
Are legends now
While trout and deer
Survive to be
Game only men
Paul Bunyan like
Could hope to snare.

The deer I shot
On Harmon Ridge,
The trout I caught

From Baker Stream,
And poachers knew
Near 'Possum Pond
Are sources now
For yarns I tell
And then repeat;
My only way
By old dirt roads
With long gone friends
In wilderness
To catch those trout
And shoot those deer
From rocking chairs.

RECALL

I'll draw the lines to mark
Where walls of stone kept trees
From pastures and a field;
I'll show where barn and house
Once stood beside the road,
Recall from days of youth
Each detail of the scene.

Then will you paint for me
A picture of the place
Where I was born and played
And drove the horse to rake
The hay my father mowed?

I pulled the garden weeds
And picked the peas and beans.
I climbed the maple tree
That grew upon the lawn.
I rode the horse bareback
For dad to cultivate;
And learned to milk the cows
When I was very young.

I'd like a picture now
To hang upon my wall,
The grape vines on an arch
Above the door in front
That got but little use;
The kitchen door most used
That opened on a porch;
Grandfather's Model T
And Spot my rabbit dog,
The shed and barn beyond;

The barn door open wide,
Some chickens in the yard;
And Dan the aged horse
Beside the tub and pump.

Each time I turn to see
That picture on my wall
I'll live again those days
Of childhood on the farm
And all the wondrous things
I learned when I was there.

PRECIOUS DAYS

How many days ahead
Along my lonely trail?
How many days of sun;
How many days of rain?

There's been so much of both
As summers came and went;
And like a winding stream
I touched the clover fields
And wandered through the woods.
I bent to see and smell
The blooms of violets,
Of daisies, buttercups
And blue forget-me-nots.
I left the blossoms there
For bees to pollinate,
That birds have seeds to eat
And some be left to grow.
The lilac sprouts I set
By corner of the house
Now shade a window there
And blossoms in the spring
Will scent the kitchen air.

I will be thankful for
Each precious day ahead;
And though it rain or snow
I'll bend to smell of blooms
Though only memories.

FOR BAREFOOT BOYS

While skating on a fire-lit pond
With childhood friends, I looked above
And saw the star that beckoned me.
A barefoot boy while raking hay,
Or milking cows or picking beans,
I dreamed of ice and Esquimeaux,
Adventure on the polar sea.
I read of men who sailed in ships
To where the sea was always ice,
Then on with dogs to pull the sleds,
Of animals and native tribes,
And wonders of a frozen land.

My urge to go was not denied
And I, one day, followed that star.
I thrilled to winds and waves at sea,
Of creak of masts and lines and sails.
I followed where my guide had been,
Had charted courses long before,
Who knew the thrills and dangers there,
And learned the words the natives spoke.
I saw the ice I'd read about,
And met the fur clad Esquimeaux.

I lived the dreams I'd often had
Those August days when feet were bare.
So few such dreams that are fulfilled,
So wonderful for barefoot boys.

TIME

There was a time
I could not wait
To get from here to there.

I think I drove
Dad's Model A
At speeds he did not know.

Perhaps I thought
The girl in mind
Had other boys in mind,

That late for date
She would not wait,
Be gone when I arrived;

And so I missed
The mountain view
Reflected on the lake.

I did not wave
To Auntie Grace
But saw her wave to me;

Nor did I stop
To make bean talk
With Grampa as he hoed.

Now time has passed.
The road still there,
Those older folks long gone.

The girl in mind

Who waited then
The one I sit beside,

Together see
The apple trees
In blossom and with fruit.

GEORGE MANN

Another old friend has died.
He waited not patiently
For his time on earth to end.
Hardly see, he could not hear,
His future but the time to wait.
Was it hours or days or weeks
Between when someone sat beside
Pressed a hand in his and smiled?"

So tired now why don't they go
Let him sleep forever more.

TOO SOON

It's done. The wood is split.
Just past the end of June
It's piled outside to dry
From summer sun and wind,
Be ready for the stove
When need for it has come.
When cold north wind, snowstorms,
Then time to start again
To cut the leafless trees,
To yard with what we have.
No ox or horse these days.
Some motor driven thing
That roars and belches smoke
And crushes smaller trees.

Too soon I'll find that cash
From sale of trees will bring
A way that's labor free
To winter warm my house,
Avoid the muscle pains,
The stiff and aching back.
Too soon I'm sure; but please,
Not yet, not yet, not yet.

REMINISCENCE

I heard the calls from far away
Of guillemots and eider ducks,
Of iron wheels on iron rails
And song of waves on tropic sand.
Though bright daylight I saw in dreams
The naked tribes and elephants,
The camel caravans and tents
And islands where the palm trees swayed.
I felt the surge of sailing ships,
The blast of cold from Arctic storms,
The warmth of sun where bathers lie;
And I was young with years ahead.

Though now it seems long long ago
I still recall the Esquimeaux,
The rows of corn beside the tracks
And sharks that sail the seven seas.
The pictures that I took confirm
The beauty of the snow clad Alps,
Gondolas by cathedral steps
And churches built of stone and thatch.
The dreams came true of sails awing,
Of ptarmigan and polar bear.
I heard strange tongues in foreign lands,
The talk of toads and unseen things
Beneath the palms on starry nights.

Then long before my time was up
My trail led back to where I'd dreamed,
To where my roots were anchored deep,
A piece of land that was my own.
I've cut my wood and shelled my beans
Upon the land my father tilled.

I've helped my neighbor if he had need
And he helped me as much or more.
I'm glad I dreamed and wandered far
And glad I still have dreams sometimes.

SILENCE

The winters long ago,
Though shoveling was a chore,
Were filled with challenges
From games of Fox and Geese
To climbing crusted drifts
That blocked the road to school.

Along the valley road
The ash from chimney smoke
Made dancing shadows on
And peppered fields of snow
Between the rows of trees
That marked the buried walls.

Except the sound of trains
That passed but once each day,
There were no engine sounds.
I hardly can recall

The silence of those times
That ended long ago.

MY SPIRIT

When I have spent my life,
My heart no longer beats,
My bones reduced to ash,
My spirit has escaped,
You'll find me if you search
In haunts among the trees,
Along a cold, clear stream,
Beside a lonely lake.

You'll find me in the spring
By yellow violets,
Where garden earth is turned,
Where rivers meet the sea.

In summer time I'll be
Where bees buzz bloom to bloom,
On shaded logging roads
With grouse and moose and deer;

In fall where maple leaves
Have felt the touch of frost,
Bring forth their wondrous change,
Where geese may land to rest
Along their flyway route.

Then come the snow and cold
My spirit sure to rest,
May hibernate with bears
Or gather heat beside
The flames where skaters rest.

My spirit life more like
A windblown butterfly

With no intent to share
My ghostly freedom with,
Nor haunt my progeny.

INDEX

ABOUT THE AUTHOR

A Maine native and University of Maine graduate, Walter Staples retired after a long career in poultry disease research. Although he lived in New Hampshire, Walter made regular blueberrying and fishing trips to Maine until his death in August 2004. His articles and poetry have appeared in a variety of publications and he is also the author of *North Bay Narrative: One Hundred Years of a Newfoundland Outport Village* (1998), and *Blueberryland: Taming the Maine Wild Lowbush Blueberry* (2003).